IMPERFECT INNOCENCE

THE DEBRA AND DENNIS SCHOLL COLLECTION

D0882354

IMPERFECT INNOCENCE

THE DEBRA AND DENNIS SCHOLL COLLECTION

ESSAYS BY
NANCY SPECTOR
JAMES RONDEAU
MICHAEL RUSH

BOWLING GREEN STATE
UNIVERSITY LIBRARIES

CONTEMPORARY MUSEUM
AND
PALM BEACH INSTITUTE OF CONTEMPORARY ART

TABLE OF CONTENTS

7 Foreword
 Michael Salcman

8 Art Photography after Photography
 Nancy Spector

16 House and home, coming and going:
 Thoughts on the Scholl Collection
 James Rondeau

22 Still Moving: Video Art in the Scholl Collection
 Michael Rush

26 Imperfect Innocence:
 An Interview with Debra and Dennis Scholl
 Gary Sangster

35 Plates: Selections from the Collection

122 Acknowledgments

124 Artist Biographies

127 Credits

Foreword

In recent years, collectors and curators of contemporary art have witnessed a significant shift in art making from traditional media such as painting and sculpture to large-scale photography, video, and digital art. Throughout its ten-year history, the Contemporary Museum of Baltimore has highlighted this change by incorporating new media into accessible and innovative exhibitions.

Imperfect Innocence is the second exhibition that the Contemporary Museum has devoted to a survey of contemporary photography. The first, *Mysterious Voyages* (1998), was mounted in a downtown bank building and was drawn from a variety of New York and local collections. However, it contained no video and was unaccompanied by a catalogue despite the fact that no similarly wide-ranging show had been produced so close to America's cultural center. In contrast, *Imperfect Innocence* begins its national tour in the new permanent headquarters of the Contemporary Museum and is drawn from a single private collection — that of Debra and Dennis Scholl of Miami Beach.

The show began its life in a most congenial manner, a seemingly casual conversation on a water taxi somewhere on the Grand Canal in Venice; it has continued to mature and grow with the same harmoniousness and generosity of spirit. Throughout the conception and execution of *Imperfect Innocence*, the helpfulness and vision of Debra and Dennis Scholl have been exemplary. Their commitment to the inclusion of video art and the production of this outstanding catalogue have expanded on the achievements of the Contemporary Museum's earlier ventures into this important territory of artistic innovation.

Imperfect Innocence, like the Contemporary itself, is primarily about ideas and how concepts become manifest in created images and objects. Unlike most surveys, *Imperfect Innocence* is not simply a gathering together of the usual suspects and their greatest visual hits. Although many of the artists are well known, like Bernd and Hilla Becher, Andreas Gursky, and Pipilotti Rist, their inclusion in the show is based on how well they support the overarching themes discussed by our essayists. We hope that many if not most of the other artists will be experienced as new discoveries by all but the most compulsive and frequent visitors to the usual contemporary art venues. This younger generation of photo-based image makers is undaunted by the quotidian inundation we all share, afloat in a sea of images and information; they seek to restore some of the magic, the innocence, even the terror of the dream in our everyday lives.

Michael Salcman
Acting President
Contemporary Museum, Baltimore

Art Photography after Photography Nancy Spector

What is the difference between a photographer and an artist who works with photography? Are there specific aesthetic criteria that determine the distinction between these two categorizations? Or is this perceived disparity merely an art historical construct that has become germane in today's visual culture, which is permeated by mechanically reproducible mediums such as photography, film, video, television, and the Internet? Such a construct allows for the division between the old and the new, or the traditional and the avant-garde. It configures entire museum departments and defines the parameters for certain private collections. It also provides a vocabulary for interpreting a diverse range of works that are, nonetheless, all crafted in the same way: light is cast on the surface of chemically treated paper to form an impression of the empirical world.

The history of photography within the fine-arts context has been one of absorption and assimilation. Originally considered the mechanical stepchild of painting, photography was devalued initially for its inherent multiplicity and seemingly automated rendering of the world. Not long after its invention in 1839, photography came to pervade every aspect of visual culture, serving as a convenient tool with which to commemorate, document, advertise, and analyze. Photography's position as an art form in its own right, with all the attendant trappings — an art historical lineage marked by technical achievements, master practitioners, and recognizable styles — evolved slowly during the first half of the twentieth century through the concerted efforts of individual curators and photographers determined to validate the aesthetic dimensions of the medium and to separate it from its more commercial applications.[1] Through devices such as the vintage print and the limited edition, which purportedly secured a work's authenticity and uniqueness, fine-art photography was able to claim the "auratic" quality that was typically the province of painting, the most venerated of art forms.[2] Artistic careers were thus born; Alfred Stieglitz, Ansel Adams, Paul Strand, Edward Weston, Diane Arbus, Gary Winogrand, and other photographers were granted their place within the hallowed halls of the museum and celebrated for the individuality of their authorial visions. Fine-art photography came to be understood as the personal expression of select creative genius, even though it was as mechanistic as its other institutional functions, like photojournalism or medical imaging.

By the 1960s and 1970s, the ascendancy of fine-art photography had been fully realized with the establishment of a market devoted specifically to the limited edition or vintage print, the proliferation of photography departments in major art museums, and the emergence of a publishing industry dedicated to photography books with high production values. Regardless of its visibility and prestige, however, fine-art photography was isolated from the more progressive practices emerging in contemporary art at the time. The 1960s marked a paradigm shift within visual culture as artists began to challenge the sacrosanct authority of the unique aesthetic object, the institutions that housed or brokered it, and the very language used to articulate it. This moment, when numerous artistic strategies arose to replace the traditions of painting and sculpture, has been described as the "dematerialization of the object."[3] Known variously as process art, body art, earthworks, postminimalism, performance, and conceptual art, much of

the work created during this period involved performative or temporal activities that were largely ephemeral. Some practices — in particular, linguistically based conceptual work — directly critiqued the epistemological nature of art, while others reinvented its terms to explore the experiential and the outer limits of the self. What linked these disparate and wide-ranging approaches was photography.

The photographic process — with its seemingly neutral, documentary capabilities — became the primary vehicle through which artists depicted their various interactions with the world, their own bodies, or other representational systems.[4] It was not, however, the cloistered and canonized tradition of fine-art photography that served as their source, but rather the veritable avalanche of photographic imagery informing society at large. While The Museum of Modern Art was staging monographic exhibitions of such photographers as Walker Evans (1971), Eugene Atget (1972), Harry Callahan (1976), and William Eggleston (1976), conceptual artists were turning to photojournalism, the amateur snapshot, and ad copy for their visual references.[5] Defined by multiple social and institutional discourses, the photograph was perceived to bridge such discrete categories as high and low art as well as information and personal expression. Photography's inherent reproducibility and potential for mass distribution were embraced as means to subvert the increasingly market-dominated art world. The photograph was thus used as a hybrid medium to create works that privileged art-as-activity over art-as-product. It functioned, for instance, as a recording device for durational events (as in projects by Jan Dibbets and Douglas Huebler); as a visual record of actions sited outside the gallery environment (Daniel Buren,

Gordon Matta-Clark. *Conical Intersect* (detail). 1975. Cibachrome print mounted on mat board. 40 ⅛ x 30". Collection Solomon R. Guggenheim Museum, New York

Richard Long, Gordon Matta-Clark, Dennis Oppenheim); as a tool to analyze the seriality inherent in architecture and industry (Bernd and Hilla Becher, Dan Graham, Hans Haacke, Ed Ruscha); as a document of the corporeal gesture (Vito Acconci, Ana Mendieta, Hannah Wilke); as a way to examine the relationship between image, text, and meaning (Robert Barry, Victor Burgin, Joseph Kosuth); as a mirror to the photographic core of our media culture (John Baldessari); and as a symbol for collective historical memory (Christian Boltanski).[6]

Since the photograph was considered to be a content carrier rather than an aesthetic object, its own immediate physical presence was, in some cases, deemed entirely unnecessary. In 1966, Graham situated his artwork in the space of a magazine, emulating the look and tone of the photo-essay with his illustrated study of suburban architecture entitled "Homes for America."[7] Like Robert Smithson's 1967 *Artforum* article, "Incidents of Mirror-Travel in the Yucatan" — an artwork posing as a hallucinatory travelogue[8] — Graham's project functioned as a parody of photojournalism while raising doubts about the artistic "autonomy" of his own photographs.[9] In fact, the illustrations for both Graham's and Smithson's articles were taken from Kodachrome color slides; Graham didn't begin printing or exhibiting his own images as independent photographs until 1970.[10]

Graham's and Smithson's critical interventions into the framework of print journalism — which, in retrospect, can be understood as parodic performances — presaged the emergence of postmodernist art by nearly a decade. Manifest as a crisis in cultural authority, postmodernism exposed the legitimizing narratives of late capitalism to be ideological constructs designed to maintain its presumed hegemony. In the visual arts, postmodernist theory was translated into a widespread suspicion of representation, which was revealed to construct ideas about identity and to perpetuate desire. Questions regarding the mechanisms of power inherent in contemporary systems of representation — advertising, television, cinema, print media, fashion, and architecture — emerged as operative aspects of the most provocative art created from the late 1970s to the mid-1980s: To whom is representation addressed and who is excluded from it? In

Dan Graham. *A Family at New Highway Restaurant; Back Yards, Tract Houses.* 1967; 1966. Two color photographs. 35 ¼ x 25 ¾" overall, framed. Courtesy Marian Goodman Gallery, New York

what ways does it define and maintain class structure, sexual difference, and racial difference? What does representation validate and what does it obstruct? And, ultimately, can the means of representation — like those of ideology, which are seamless, transparent, and always present — be critiqued, dismantled, or transformed?

The medium most suited to stage this critique of representation and its multiple discourses was photography. In fact, interventionist, photo-based practices became the defining aesthetic mode of postmodernist art. Described by Abigail Solomon-Godeau in 1984 as "photography after art photography,"[11] this work adhered principally to two different but overlapping conceptual strategies: appropriation and simulation. In the former category, Sherrie Levine rephotographed existing, well-known art photography and claimed it as her own in the series *After Walker Evans* (1981). While often interpreted as an ironic critique of modernism's cult of the original, this appropriated work also has a strong feminist subtext. By directly seizing the iconic products of modern photographic masters, Levine refused the supremacy of authorship, her own and that of her paternal elders. She staged this challenge within and against a culture that has routinely privileged artistic creativity as a male prerogative. In a similarly critical fashion, Richard Prince culled the image world of mass advertising to rephotograph emblematic images of American consumer culture — the Marlboro Man, the fashionably dressed woman, and scantily clad biker chicks — to self-consciously reveal the packaging of masculinity and its attributes.

Following a related strategy of simulation, Cindy Sherman also repeated or reasserted vernacular imagery, but by restaging celluloid stereotypes of femininity. Her early photographic reenactments of "B" Hollywood movie scenes unveil the performative nature of gender construction. Conceived as black-and-white "self-portraits" — each one utilizing a different disguise to depict a heroine at risk, in love, or weary from indifference — these "film stills" initiated Sherman's ongoing interrogation of vision and its relationship to sexuality. Formulated by what A. D. Coleman has designated the "directorial mode," Sherman's artfully constructed mise-en-scènes parody the

Cindy Sherman. *Untitled Film Still, #58*. 1980. Gelatin-silver print. 5 ⅜ x 9 ⁵⁄₁₆". Collection Solomon R. Guggenheim Museum, New York

different pictorial venues through which woman is represented in today's image-saturated culture: Hollywood cinema, fashion, society portraiture, pornography, and so on.[12]

The oppositional aspects of postmodernist art were quickly absorbed by the institutions they sought to critique, as is most often the case with any culturally subversive avant-garde practice.[13] Postmodernism easily entered art historical discourse, and critics promptly acknowledged the appearance of a new "movement," identifying its various tendencies as "neo-geo," "post-conceptual," or "simulacral." Its practitioners immediately gained commercial representation — in fact, galleries such as International with Monument and Metro Pictures, which opened in 1980, were founded in direct response to, and in tandem with, the emergence of postmodernist practices in the visual arts. Museums in Europe and the United States soon organized exhibitions that examined the phenomenon. Some of the more noted of these shows included *Image Scavengers: Photography* (1982) at the ICA in Philadelphia, *A Fatal Attraction: Art and the Media* (1982) at the Renaissance Society in Chicago, and *Damaged Goods: Desire and the Economy of the Object* (1986) at the New Museum of Contemporary Art in New York. In 1989, the Museum of Contemporary Art in Los Angeles presented *A Forest of Signs: Art in the Crisis of Representation* as a summation of the decade's postmodernist impulses; the show's catalogue includes individual texts on the thirty featured artists, three art historical essays, and an illustrated exhibition history. Given the critical dimensions of postmodernist art and its theoretical sources in poststructuralist, linguistic studies, the art of this decade engendered an unprecedented amount of analytical text. Postmodernism's champions announced its advent and predicted its demise.

In an essay written three years after the publication of her pivotal text "Photography after Art Photography," Solomon-Godeau lamented the failure of postmodernist art to remain detached from the institutions it evolved to critique.[14] In her mind, the acceptance of such art by the museum signaled its corruption and the individual artist's complicity with the market. Postmodernism, she noted, had become just another style. What did this condemnation mean for the effi-

cacy of the actual artwork and the continued relevance of the artists' careers that she so summarily dismissed? According to Solomon-Godeau and other critics associated with postmodernist theory, fine-art photography was merely an invention of the market/museum axis that determines which art receives mainstream attention, and postmodernist photography was ruined by this alliance once it gained acceptability.[15] Such an argument allows little room for artists to succeed unless they remain outside of all legitimizing systems.

Much of the best work created during the 1990s attempted to bridge the gap between institutional validation and alternative structures. From Rirkrit Tiravanija's communal Thai dinners to Felix Gonzalez-Torres's endlessly replaceable stacks of imprinted paper and piles of edible sweets, artists sought to engage the public through interrelational artworks. The proliferation of photography, film, and video during this decade occurred partly through the need to record the performative aspects of these ephemeral practices, which, in some cases, marked a return to a 1970s aesthetic of "dematerialization." But the current pervasiveness of photo-based activities also seems to be a recuperation of *both* fine-art aesthetics and conceptual strategies. Today's photo-based art boasts an intricate, multilayered genealogy that draws on numerous and often conflicting traditions. It is a polymorphous, expansive medium that includes video, film, and new digital technologies, as well as fresh interpretations of conventional, straight photography. Numerous artists, for instance, have responded to the documentary impulse that informed so much fine-art photography. In the realm of portraiture, Rineke Dijkstra's disquieting images of children on the verge of adolescence, Hellen van Meene's intimate portrayals of young girls, Katy Grannan's depictions of people fantasizing their own representations, and Catherine Opie's pictures of butch dikes and transgendered individuals combine the dispassionate, typological studies of August Sander with the aestheticizing visions of Richard Avedon or Robert Mapplethorpe.

Photography's relationship to typological analysis — as evident in Sander's systematic catalogue of German portraits entitled *Citizens of the Twentieth*

Century (1918–33), the Bechers' ongoing inventory of industrial relics, and Ruscha's booklet recording every building on the Sunset Strip (1966) — is well manifest in photo-based art today. For instance, Olafur Eliasson's photographic grids, each depicting a single example of a natural phenomenon shot from the same vantage point, recall the visual rigor of the Bechers' photographic formations. Candida Höfer, a former student of the Bechers, creates ordered, color photographs of building interiors — with an emphasis on places of learning and classification — that subtly investigate the psychology of public space. Choosing as her subjects libraries, museums, lecture halls, theaters, and waiting rooms, she documents the architecture of society's communal experiences and its compulsion for taxonomic systems. Andreas Gursky inventories late-capitalist society and the means of exchange that organize it. His precisely composed images reproduce the collective mythologies that fuel contemporary culture: travel and leisure (sporting events, clubs, airports, hotel interiors, art galleries), finance (stock exchanges, sites of commerce), material production (factories, production lines), and information (libraries, museums, book pages, data). Yet, despite the traditions he invokes both formally and conceptually, Gursky has no pretense to objectivity. He digitally manipulates his images — combining discrete views of the same subject, deleting extraneous details, enhancing colors — to create a kind of "assisted realism."

The development of digital technologies has given artists enormous latitude in the invention of their photographic images. Contrary to some beliefs, photography has never been a purely objective medium providing an unmediated view of reality. Everything, from vantage point to printing process, makes one picture different from another, even if they are of the exact same subject. Furthermore, the camera can record the most outrageous untruths by manipulating the visible or indulging in total fantasy. The 1990s witnessed an explosion of photographic fiction. Immediate art historical sources for this phenomenon may be found in Sherman's parade of invented personae or James Casebere's photographs of paper constructions suggesting uninhabited cities from the late 1970s. But it is more the impact of cinema and television today that has given rise to the new narrative photography. Artists now freely manipulate their representations of the empirical world or invent entirely new cosmologies. Some, like Gabriel Orozco, directly intervene in the environment, subtly shifting components of the found world and establishing their quiet presence in it. Others, like Thomas Demand or Gregory Crewdson, fabricate entire architectural settings for the camera lens. Working from preexisting, journalistic photographs of banal environments where extraordinary or atrocious things have occurred — Bill Gates's college desk, Jackson Pollock's barn, Jeffrey Dahmer's hallway — Demand builds one-to-one scale models of his subjects. The resulting photographs only intimate the historical weight of their settings with an uncanny, uncaptioned silence. In a similar vein, Crewdson once constructed elaborate, small-scale dioramas of generic neighborhood backyards, in which the flora and fauna enacted strange rituals: birds built a circle out of eggs; butterflies congregated to form a pyramid; vines turned into braids. Each of these miniature worlds would render a single photograph. In subsequent work, Crewdson expanded his subject matter to include images of small-town life strangely out of sync with reality — much in the spirit of David Lynch. Shot in and around Lee, Massachusetts, these surreal photographs were constructed with the scale and intricacy of film sets.

Photography and film share the same genetic code, but it is only in recent years that artists have begun to fully exploit this fact in photographs that depict moments from larger, fantastical tales. Unhampered by photography's intrinsic stillness, Anna Gaskell stages mysterious mise-en-scènes for the camera, each one an evocative passage from a larger narrative. Her photographic fictions circulate around processes of make-believe — from the innocence of children's games to the anguish of mental illness. Built from layers of untruth, they bring into focus the tenuous distinction between reality and the imaginary. Gaskell has also translated her imagery into videos, extending in time the strange fairy tales invoked by her still photography. Matthew Barney, perhaps *the* paradigmatic storyteller of the 1990s and beyond, creates photographs that distill essential moments from the plots of his epic films. His five-part *Cremaster* project (1994–2002) has engendered a rich body

of photographic work that pronounces the significance of pure invention in contemporary art today.

The prevalence of photo-based practices in recent art has yet to be theorized. In many ways, the sheer profusion of photography, in all its polymorphous manifestations — black-and-white prints, Cibachromes, film stills, digital imagery, and so on — rejects the kind of critical analysis that determines specific art historical movements or medium-based categories. Photography has become common parlance today in a way that painting or sculpture never could. Its ubiquity in all forms of visual culture complicates photography's reception as a purely artistic medium, particularly since artists freely draw from, emulate, and/or critique the image world at large. What is clear, however, is that the mistrust of visual representation that informed the most radical and important photo-based art of the 1980s has subsided, at least for the moment. It remains to be seen where the current exuberance for photography will lead.

NANCY SPECTOR IS CURATOR OF CONTEMPORARY ART AT THE SOLOMON R. GUGGENHEIM MUSEUM, NEW YORK, WHERE SHE HAS ORGANIZED EXHIBITIONS ON CONCEPTUAL PHOTOGRAPHY, THE WORK OF FELIX GONZALEZ-TORRES, AND, MOST RECENTLY, MATTHEW BARNEY'S *CREMASTER* CYCLE.

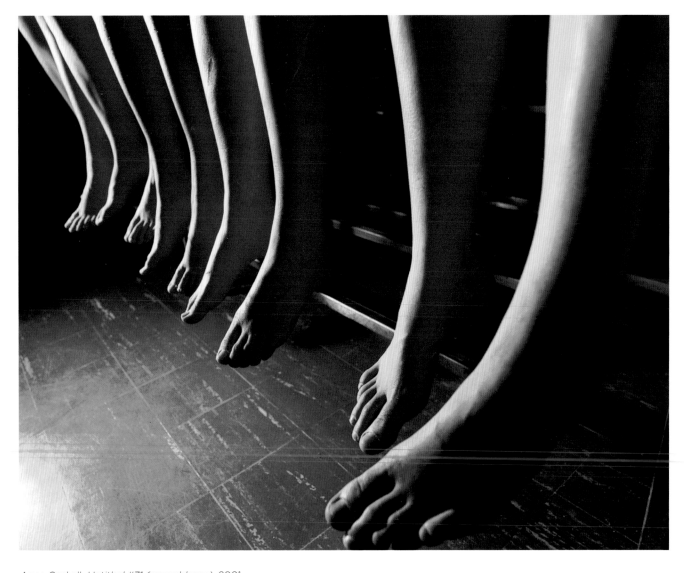

Anna Gaskell. *Untitled #71 (resemblance)*. 2001.
C-print. 59 ¾ x 74". Collection Debra and Dennis Scholl

Notes

1. Christopher Phillips documents the transformation of photography into a highly valued museum art form through a detailed analysis of the evolution of The Museum of Modern Art's photography department from 1935 with the arrival of Beaumont Newhall, the museum's first curator of photography, to the early 1980s and the tenure of Peter Galassi. He reveals ways in which the modernist values of authenticity, originality, and medium specificity were brought to bear, often retrospectively, on the photographic print. See "The Judgement Seat of Photography," *October* 22 (fall 1982), 27–63.

2. The conversion of photography, with all its attendant applications in the commercial and scientific realms, into a fine-art form, can be seen as a complete inverse of Walter Benjamin's celebration of the medium precisely for its loss of the "aura," that privileged, quasi-mystical quality associated with singular, irreplaceable art objects. Benjamin saw in photography a liberating potential for shifting the values of bourgeois culture. See Walter Benjamin, "The Work of Art in the Age of Mechanical Reproduction," trans. Harry Zohn, in *Illuminations* (New York: Schocken Books, 1969), 217–51.

3. In 1967, Lucy Lippard and John Chandler wrote, "During the 1960's, the anti-intellectual, emotional/intuitive processes of art-making characteristic of the last two decades have begun to give way to an ultra-conceptual art that emphasizes the thinking process almost exclusively. . . . Such a trend appears to be provoking a profound dematerialization of art, especially of art as object, and if it continues to prevail, it may result in the object's becoming wholly obsolete." See Lucy R. Lippard and John Chandler, "The Dematerialization of Art," *Art International* 12 (Feb. 1968), 31.

4. It was also during this period that artists such as Vito Acconci, Peter Campus, Dan Graham, and Bruce Nauman began to utilize film and the more portable technology of video to record their performative activities.

5. The phenomenon of borrowing from popular culture for artistic source material was not unprecedented. The European avant-garde of the 1920s and 1930s, including such artists as Hannah Höch and John Heartfield, developed the photographic montage as a form of political critique. And American artists of the 1960s such as Robert Rauschenberg and Andy Warhol transformed their painting practices with photographic techniques, albeit to different ends.

6. This listing of artists and the various ways in which photography was utilized during the 1960s and 1970s is by no means complete. For a more detailed analysis of conceptual photography than this brief essay will allow, see Christopher Phillips, "The Phantom Image: Photography within Postwar European and American Art," in *L'Immagine riflessa* (Prato: Museo Pecci, 1995), 142–52.

7. See Dan Graham, "Homes for America," *Arts Magazine* 41 (Dec. 1966–Jan. 1967), 21–21.

8. Robert Smithson, "Incidents of Mirror-Travel in the Yucatan," *Artforum* 8 (Sept. 1969), 28–33.

9. This point is made by Jeff Wall in his critical investigation of conceptual photography, "Marks of Indifference: Aspects of Photography in, or as, Conceptual Art," in *Reconsidering the Object of Art: 1965–1975* (Los Angeles and Cambridge, Mass.: Museum of Contemporary Art and MIT Press, 1995), 252, 257.

10. Smithson never actually printed or editioned his photographs. When the Solomon R. Guggenheim Museum purchased his *Yucatan Mirror Displacements (1–9)* of 1969, the images used to illustrate his *Artforum* article, it acquired nine color slides.

11. Abigail Solomon-Godeau, "Photography after Art Photography," in Brian Wallis, ed., *Art after Modernism* (New York: New Museum of Contemporary Art, 1984), 75–85. In this important essay, Solomon-Godeau makes the crucial distinction between postmodernist photography and fine-art photography, which "lies in the former's potential for institutional and/or representational critique, analysis, or address, and the latter's deep-seated inability to acknowledge any need even to think about such matters" (77).

12. A. D. Coleman, "The Directorial Mode: Notes Toward a Definition," *Artforum* 15 (Sept. 1976), 55–61.

13. The term "oppositional postmodernism" is Hal Foster's. See his "Postmodernism: A Preface," in Hal Foster, ed., *The Anti-Aesthetic: Essays on Postmodern Culture* (Seattle: Bay Press, 1983), xi.

14. See Abigail Solomon-Godeau, "Living with Contradictions: Critical Practices in the Age of Supply-Side Aesthetics," in Carol Squiers, ed., *The Critical Image: Essays on Contemporary Photography* (Seattle: Bay Press, 1990), 59–79.

15. In addition to texts by Christopher Phillips and Abigail Solomon-Godeau, see Douglas Crimp, "On the Museum's Ruins," in Hal Foster, ed., *The Anti-Aesthetic*, 43–56.

House and home, coming and going: Thoughts on the Scholl Collection
James Rondeau

The photographic image is one of the fundamental tools we have at our disposal with which to understand ourselves and the world in which we live. In one manner or another, many of us collect, acquire, display, exchange, and even make photographs. We are implicated in economies of information, memory, and self-representation that are, in ways both subtle and overt, structured by the photos in our home. Informal portraits of friends and family members or holiday snapshots are simply the most obvious or common points of reference in this regard. In these and other examples, the home remains a principal locus for the presentation of the photograph. The refrigerator door, a corkboard, a computer screen, a side table, even a piano — all these objects in a domestic setting are recognized both for their original use value as well as for their role as support surfaces for photographs.

This short essay is occasioned by *Imperfect Innocence,* a touring exhibition and accompanying publication featuring selections from the collection of contemporary photography acquired over the last decade or so by Debra and Dennis Scholl. In reflecting on both how and why we live with photographs, I recall an exceptional project by the artist Christian Boltanski, whose own work is not included here but whose piece makes explicit the connection between the near ubiquitous practice of assembling a photographic archive of one's own life experiences and the strangely parallel process of acquiring and presenting a collection of contemporary art photography. In 1995, as part of a larger show called *Living with Contemporary Art* (organized by the Aldrich Museum of Contemporary Art, Ridgefield, Connecticut), Boltanksi invited two unrelated families living in the same town to select, exchange, and install in their homes nearly one hundred images from one another's collection of family photographs. For a specified period of time, the two households lived with representations of landscapes and buildings that were not familiar, portraits of individuals (alone and in groups) they did not know, and documentation of events in which they did not participate. Boltanski's gesture was at once innocent and ingenious, simple and complex: it transformed a set of vernacular mementos too often taken for granted into an abstract, challenging set of representations that required study and imagination. By altering the context, Boltanski necessitated the writing of wholly new narratives to support the pictures. The strategic reversal asked both families to take temporary ownership of images that at first appeared strange or foreign and then, by living with the photos, to begin to unlock their formal and conceptual possibilities. Underscoring his point and its ramifications, the artist installed copies of both collections — intermingled — at the Aldrich Museum. (Within the context of the Scholls' holdings, it is worth noting that Boltanski unintentionally reminds us that the journey of a collection from a home to a museum, rendered uncanny in this case, is, of course, not uncommon, always elaborate, and, often desirable.)

As the Aldrich project aptly demonstrates, one person's family photographs can become another person's art collection; one person's facts can become another's fictions. While the degrees of formal accomplishment, finish, scale, and cost — as well as the distribution methodologies involved — vary between these two models of photographic collecting, their effect is essentially the same: all of us, in some fashion, endeavor to gain knowledge and insight, to remember and to memorialize, to fantasize

and to entertain, and, in the largest possible sense, to reimagine ourselves through the presentation of photographs within the spaces in which we live. Turning one's own home over to a collection of noted, international contemporary art photography, as the Scholls do, simply makes the process more legible, more ambitious, and, as a possible consequence, more public.

———

Boltanski's inspired gesture finds a corollary of sorts in the curatorial management practiced by Debra and Dennis Scholl — specifically as it pertains to the ongoing reinstallation of their impressive and growing collection of contemporary photography, video, and, to a lesser degree, sculpture. Once a year for the last several years, the Scholls have invited a museum-affiliated contemporary art curator to make selections from their holdings and to install the chosen works in their home. They provide the curator with a complete checklist of the pieces, a team of skilled art handlers, an empty house, and total autonomy in decisions of inclusion, exclusion, and placement. Temporarily surrendering both their property and their creative control, the Scholls return to discover a new constellation of meaning in the public and (formerly) private spaces of their residence. The experience, one could presume, is not entirely different from coming home and finding another person's family photographs installed around the house. Granted, the Scholls can claim an original agency in the identification and purchase of the art in question, but, the notion that the deployment of photographic images can constitute, reconstitute, even transform one's own environment is similarly made apparent.

The strategic transfer of curatorial oversight is fundamentally connected to the nature of the conceptual photography that forms the bulk of the Scholls' holdings. By inviting continual reinterpretations of the changing but given reality that is their collection, they acknowledge that subjectivity, play, manipulation, and altered perception are essential working assumptions and goals for many of the artists whose images they have assembled. That contemporary fine-art photography is no longer bound to myths of empirical fact seems precisely the source of its present power and

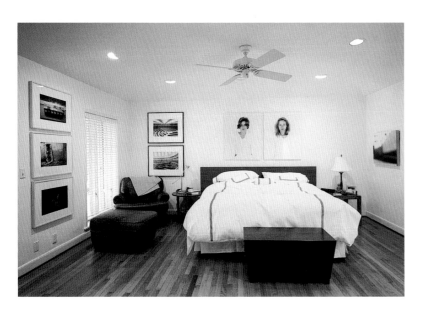

Bedroom of Debra and Dennis Scholl, curated by Connie Butler, 2001

allure — indeed, of its centrality to the art of the last thirty years. The rise of collecting photography, the emergence of a strong international market for large-scale photographs, the creation of college and university studio art programs with a focus on photography — all these developments are nearly coincident with the proliferation of theories in which a belief in the veracity of photographs was abandoned and a new set of willfully false documents, constructed realities, and subversive texts was embraced. The critical arguments surrounding questions of photography and "truth" have been well rehearsed; here it is sufficient simply to note the preponderance of established contemporary photographers who rely upon directorial modes, costume and constructed artifices, or computer-based manipulations in order to produce their images.

For each of the artists discussed below — and for a significant number of other artists represented in the Scholl collection — the camera is not deployed as a self-reflexive tool to make photographs about the medium itself, but rather is used as a strategic apparatus in the service of an idea-based process of image making. In other words, we are looking at a critical mass of artists who use photography as a tool, but whose creative work in many respects is not contained by the photographic process. Many of us cling to our belief in the photographs that result not out of a misguided desire to apprehend the real, but instead because these new images produce new knowledge. In a picture-saturated world, this work helps us to negotiate the perpetual psychic oscillation between the real and its myriad alternatives.

———

Given the domestic origins of the Scholl collection, it is a poetic congruence that allows one to track the representation of house and home — in particular, the middle-class suburban home — as a locus for creativity, indeed, as an emblem of the ways in which contemporary photographic practice can record and confuse ideas of place and perception. While perambulating the Scholls' own comfortable, remarkably unpretentious home — or, at other times, traversing the gallery spaces of a museum where selections from their collection are presented — we can trace a

Dan Graham. *Tract Houses, Bayonne; New Housing, Vancouver.* 1966; 1974. Two color photographs. 35 ¼ x 25 ¾" overall, framed. Courtesy Marian Goodman Gallery, New York

changing idea of house and home from the beginnings of conceptual photography in the 1960s to the present. Within this small microcosm of a larger art history, the house and home emerge as fact and later recede from view amid aggregate fictions. From Dan Graham's earnest explorations of home as a source of socioeconomic data, Gordon Matta-Clark's early fascination with house as a sculptural potential, Gregory Crewdson's curious interest in the cinematic possibilities of the larger suburban context, and Gregor Schneider's obsessive transformation of his own house into a purely sculptural odyssey, a trajectory with many parallel narratives in the Scholl collection can be extrapolated.

Graham, who began his career in the visual arts in 1964 as a gallerist, produced his first artwork as a photo-essay for *Arts Magazine* in December 1966–January 1967. The now landmark "Homes for America" (1966–67) offered an analytical description of tract houses in suburban communities in New Jersey (complete with a typical floor plan, lists of the ersatz poetic language used for the house styles and available colors, as well as the likes and dislikes of style sorted by gender, and so on). Both *New Houses behind Chain Link Fence, Jersey City, N.J.* (1966), which was in the photo-essay, and *Housing Project, Staten Island, N.Y., 1974, 212–221, Two Home House Entrance, Staten Island, N.Y., 1976* (1974–76), a later double-image that responded to the comparative format of the original project, evidence Graham's early conceptual investigations. These class-inflected, quasi-scientific examinations of everyday life were filtered — somewhat ironically and critically — through the prevailing artistic paradigms dealing with consumer culture, repetition, seriality, and minimal form. In this context, Graham's vision of the suburban home as a component of larger, endlessly repeatable "projects" exposed the dehumanizing aspects of a then-new residential idiom. Within this system, the home existed for Graham as a fixed, largely exteriorized reality (the interior "decorative" mutations of which were quietly trivialized), and individual inhabitants were, in the artist's own words, "tangential."

Matta-Clark shared Graham's desire to register a critique of property — domestic and other — and succeeded in offering a radical vision of repossession.

Rather than study the structures in the way Graham did, Matta-Clark acted upon them. The artist is best known for a series of "building cuts," executed between 1972 and 1978, in which he carved sections out of old buildings, treating them (in the manner of modern sculptures) as spatial compositions. Calling these transformations "Anarchitecture," Matta-Clark carved or sculpted the buildings with a chain saw and documented the changes in films and photographs, which he subsequently exhibited in galleries, often alongside fragments of the buildings themselves. As evidenced by the cleverly titled *A W-Hole House* (1973), a diptych that documents from an aerial perspective Matta-Clark's first officially sanctioned cutting of an entire structure, the vernacular syntax of "home" (as opposed to simply "building") was essential to the early development of his practice. In this seminal work, the artist explored the "object-like treatment of the suburban home." He continued: "The notion of mutable space is taboo especially in one's own home. People live in their space with a temerity that is frightening. Home owners generally do little more than maintain their property."[1] Matta-Clark, however, insisted upon such structures as the basis for a revolutionary reimagining of the entire urban landscape.

While Matta-Clark extended his interests into the larger fabric of urban life, Crewdson activates the clichéd surroundings of the suburban house by means of surreal, theatrical interventions. He is a leader among a younger generation of artists who use photography to explore the appearance of reality as gauged by the possibilities of fictional narrative. A 1988 graduate of Yale University who now teaches there, Crewdson has exerted a broad influence in shaping a group of artists who utilize photography to capture construction, performance, or calibrated spectacle. His own work draws on cinematic practice to create obsessively staged charades that often require the assistance of prop masters, actors, production designers, and special-effects coordinators. For nearly ten years, Crewdson has led a team of collaborators back to the same small town in western Massachusetts, where they stage poetic, often mysterious suburban docudramas or, more accurately, psychodramas that are equal parts *Leave It to Beaver* and David Lynch. *Hover* is a series of black-and-white photographs the artist

made from the vantage of a cherry-picker in 1996 and 1997. In *Untitled* (1997) from this series, the neighbors and even the police gather to watch in stunned amazement as one of their own attempts to extend his lawn into and across the street. The image seems to give pictorial form to a desire to graft the home on to a larger, shared space, to transgress the tidy lines that demarcate private property and public interest. In this and other images, Crewdson expresses the longing of his semi-fictionalized suburban inhabitants to connect and merge with a world or worlds outside of their own.

With regard to issues of photographic practice and home, Schneider's work represents a strange, claustrophobic, even vaguely macabre endgame. The artist is engaged in the process of remaking his world, and the center of his activity is his house, the so-called *Haus ur* in Rheydt, Germany. Since 1985, Schneider has been adding layers of structure (false walls, ceilings, new windows and doors, and the like) within existing rooms of a modest multistory home he acquired from his parents. Years of sustained effort have led to a dense warren of blind alleys, hidden rooms, rotating floors, and cul de sacs. Like Graham and Matta-Clark, Schneider is an architectural sculptor who uses photography as a means to other ends, and like Crewdson, he is an artist who uses it to record his intricate, temporal efforts. The small, almost dingy photographic prints of the *Haus ur* interiors, executed in a serial format and presented salon style, mimic the atmospheric and tonal qualities of his dirgelike environments. The ultimate deconstruction of both the home and the genre of photographs of home comes with the literal breakdown of the built environment, when the artist sanctions the removal of some or all of the rooms in the house for exhibition in other locations. Obliterated by accretion, overdetermined by materials, and then dismembered, the house becomes a new form of nonsite, a specter of home, and, finally, a set of new places in the world.

Gordon Matta-Clark. *A W-Hole House: Roof Top Atrium (roof & int. views)* (detail). 1973. Black-and-white vintage photographs. 19 ⅛ x 37 ¼". Courtesy David Zwirner, New York

The *Haus ur* is, in a sense, a home given over to art, which is then reconfigured, shipped out, and reordered in public spaces. The Scholl house and collection can be considered, with a certain kind of liberal permis-

sion, in analogous terms. While lacking the extremes of *Haus ur*, it remains a house changed and changing, where objects and images pass from private to public to private and back again. It is a house of new pictures — made with both strategic and incidental uses of a camera — which, in turn, create their own new and larger fictions. These pictures are realized by artists who conceive ephemeral worlds through the vehicle of the image, and who invite us to envision our own worlds under the influence of their efforts. Again Matta-Clark's curious admonition of homeowners who live in their spaces with temerity comes to mind. If, indeed, radical artists make images that enable us to better understand ourselves and the present, then the Scholl collection helps us to recognize a way to occupy a home, not with reckless abandon, but with an adventurous spirit, analytical skills, a serious interest in new ideas, and wide-open eyes.

JAMES RONDEAU IS ACTING DEPARTMENT HEAD, MODERN AND CONTEMPORARY ART, AT THE ART INSTITUTE OF CHICAGO. HE HAS ORGANIZED EXHIBITIONS ON THE WORK OF SUCH ARTISTS AS THOMAS HIRSCHHORN, RINEKE DIJKSTRA, AND ARNOLD ODERMATT. IN 2001, RONDEAU SERVED AS CO-COMMISSIONER FOR THE U.S. PAVILION AT THE VENICE BIENNIAL, WHICH FEATURED ARTIST ROBERT GOBER.

Note

1. Gordon Matta-Clark, quoted in *Gordon Matta-Clark,* exh. cat. (Antwerp: ICC Internationaal Cultureel Centrum, 1977), 9.

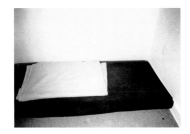

Gregor Schneider. *Haus ur* (5 details). 1985–97. Framed black-and-white photographs. 100 x 76" overall. Collection Debra and Dennis Scholl

Still Moving: Video Art in the Scholl Collection Michael Rush

Since the earliest days of photography, artists have wanted their cameras to capture movement. The well-known images of Eadweard Muybridge (1830–1904) and Etienne-Jules Marey (1830–1904) of horses running and people walking up steps may look to the postmodern eye like experiments in conceptual photography, but these late-nineteenth-century photographs, or chronophotographs, as they were called, were attempts to supercede the static by capturing motion even with the confines of a still camera. Marey's exquisite *Movements of a White Horse* (1885–86) may be described as ecstatic in its energy and prescient in its apparent artful abstraction that makes movement at once mysterious and universal.

The American painter Thomas Eakins (1844–1916) was so impressed when he met Muybridge in 1883 in Philadelphia that he, too, used a camera similar to the so-called Marey-wheel camera to capture the athletic sprints and jumps of some of his subjects familiar to us from paintings (*Jesse Godley*, chronophotograph, 1884; *George Reynolds*, chronophotograph, 1884 or 1885).[1] The next great leap for artists and their fascination with the moving image occurred in 1965, when the portable video camera became available in Germany and the United States. This is not to bypass all the experimental filmmakers from Georges Méliès in the late nineteenth century to artists like Stan Brakhage and Robert Beavers working today, but for *visual* artists who nonetheless were attracted to the moving image as an extension of their art practice, video became an accessible medium. And now, since the advent of digital video technology in the mid-1990s, the moving image has become ubiquitous in art, including photography. Of the more than forty

photographers in *Imperfect Innocence*, more than half are also video/filmmakers. Of these, several, including Doug Aitken, Matthew Barney, Stan Douglas, Douglas Gordon, and Pipilotti Rist, are among the most celebrated filmic artists in contemporary art.[2]

The carefully chosen videos from the collection of Debra and Dennis Scholl illustrate the two most salient aspects of video in contemporary art: the ascendancy of women and the centrality of perform-

Pipilotti Rist. *I'm Not the Girl Who Misses Much*. 1986. Video, color, sound. 5 min. Collection Debra and Dennis Scholl

ance. Other artists in the collection, including Janine Antoni, Tacita Dean, Zhang Huan, and, especially, Bruce Nauman, are also known for their work in performance and video. That the majority of video works presented here are by women is hardly accidental. Since the earliest days of video, female artists have been prominent pioneers of the form. From Dara Birnbaum, Valie Export, Joan Jonas, Martha Rosler, to name but a few from the late 1960s and early 1970s, to Shirin Neshat, Rist, Sam Taylor-Wood, and the dozens of others appearing regularly in international exhibitions today, women have achieved significantly more visibility in video art than in any other medium. By the mid-1960s, women in Western cultures became increasingly vocal in countering the silence that had surrounded their life and work. Since this time frame coincided with the introduction of video art, the influence of the feminist movement on the genre was substantial.

The women artists included in *Imperfect Innocence* are clear descendants of such innovators as Marina Abramovic, Export, and Jonas. Rist's *I'm Not the Girl Who Misses Much* (1986) is a speeded-up homage to Abramovic's *Freeing the Body* (1975), in which the artist danced to a drumbeat so furiously that she eventually collapsed. Rist, with her hair manically frizzed and wearing a dress that barely covers her body, dances and sings the words of a John Lennon tune. As she moves faster and faster, aided by editing technology, she looks like a wind-up doll who has lost all sense of control as she tries to "please" her audience. Rist, who is also the lead singer of the band Les Reines Prochaines and something of a pop star in Europe, is no stranger to audience adulation, but here she seems to resist it, wanting instead to expose the abuse women can suffer trying to satisfy the male gaze.

With *Pickel Porno* (1992), Rist is having fun with all the postproduction editing techniques that became popular in the early 1990s, having been introduced in less sophisticated form twenty years earlier by such artists and engineers as Shuya Abe (who developed video synthesizers with Nam June Paik), Steina and Woody Vasulka, and Ed Emshwiller. *Pickel Porno*, after opening with shots of a woman in a lemon-yellow

dress and gray strapped heels walking over a street grate toward a man in a blue coat, becomes a kaleidoscopic treatment of lovemaking. Crosscuts from tropical flowers to exploding volcanoes and close-ups of bodies accompanied by an ethereal sound track add up to a surreal journey through and around eroticized bodies.

Rist's fluid camera and attention to color (reds, oranges, bright blues) are reminiscent of the work of another Swiss artist, Jean-Luc Godard, from whom Rist has clearly learned a great deal. *Pickel Porno* anticipates her *Ever Is Over All* (1997) a masterful Godard-infused short video in which a woman wearing a breezy blue dress walks confidently down a pristine Geneva street, smashing car windows with a steel rod shaped like a flower.

In her recent pieces, including one projected on a screen in the middle of New York's Times Square, Rist has continued to explore the body in pastoral settings. Both feminist and performative, her videos are also richly cinematic.

Cinematic is also an apt description for the work (including drawings, photographs, and videos) of Anna Gaskell. On the occasion of Gaskell's solo exhibition at the Museum of Contemporary Art, Miami, in 1998, Bonnie Clearwater wrote, "Gaskell exaggerates and isolates movement in her 'wonder' photographs and eliminates framing elements that would ground the figures. As a result, her pictures defy the conventions of still photography by suggesting continuous action."[3] Gaskell's video *floater*, however, seems to

Anna Gaskell. *floater*. 1997. 16mm color film transferred to DVD. 1 min. Collection Debra and Dennis Scholl

suggest stillness. In it, the body of a young girl (looking at first like a life-size doll) is suspended, apparently lifeless, in water. As the camera lingers on her, her body rolls onto its back and her head arches toward the camera, which zooms into her open mouth. Even though it appears that the girl is dead, Gaskell creates an eerie expectation that perhaps she isn't. This undelineated boundary between the known and the unknown is characteristic of Gaskell's work with girls and young women. In her narrative photographs, these females, dramatically lit and provocatively posed, try on dark emotions or step gingerly into an adult world for which they are unprepared. The final image in *Floater,* the open mouth, is an invitation to enter, like Alice, into an underworld, which in this case may be the land of the dead. We don't know, and Gaskell, like any weaver of gothic tales, isn't going to tell us. That the video is projected onto the floor only heightens the voyeuristic participation of the viewer.

Mariko Mori's world, though equally scary to some, is anything but gothic. Her domain is the future, and in it the girls get to dress up in the most outrageous costumes: think Grace Jones meets the techno Diva Starz dolls. In *Miko no Inori* (1996), the artist, fully decked out in a silver wig and a shiny, white space outfit, rolls a glass ball around in her cupped hands. Throughout the New-Age electronic sound track (not unlike one of Rist's), the one discernible phrase to Western ears is "wait and see."

Mori heightens the enigmatic air of the scene by choosing a shopping center (perhaps an under-

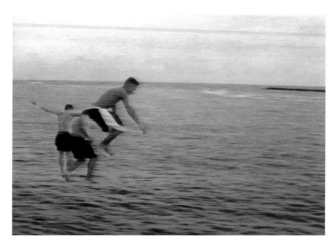

Dara Friedman. *Government Cut Freestyle*. 1998. Silent film loop transferred to DVD. 9 min., 20 sec. Collection Debra and Dennis Scholl

ground one) as the setting, as if to say places like this are as otherworldly as anything on *Star Trek*. In her installations, photos, and videos, Mori seems to be the supreme escape artist: creating clothes and contraptions designed for time travel to far-off lands. Actually, she is the most earthbound of artists, designing fantasies for people all too grounded in the everyday. She offers a way to feel singular in a homogenized world, much like artists from Ziggy Stardust to Hedwig (with her angry inch) do.

Dara Friedman's vigorous performance videos and films are as much about time as they are about action. In *Government Cut Freestyle* (1998), young men and women leap into the ocean (a safer landing spot than the pavement in Yves Klein's infamous photo, *Leap into the Void* [1960]). Gradually, Friedman's camera reveals that they are jumping from a pier, not as in some sporting event, but simply as a personal challenge to jump from a high place, with all that such an action suggests. Some do flips, some graceful dives; others just jump, hoping for the best. Through it all, the viewer shares in the exhilaration and fear of these people's optimistic leaps. Friedman made this tape in the same year as her film *Total*, a relentless, rage-filled study of destruction featuring the artist herself tearing apart a motel room. *Government Cut* is a companion piece, the sunny bookend to *Total*. In both, Friedman exercises her power as filmmaker to manipulate time, a desire we all have. In *Total,* she makes time go in reverse (the room is

Mariko Mori. *Miko no Inori*. 1996. Video, color, sound. 29 min., 30 sec. Collection Debra and Dennis Scholl

miraculously put back together as the film is run backward); in the continuous loop of *Government Cut,* time seems to disappear, as the sun never sets on these young divers taking their chances on the sea.

Paul Pfeiffer has also made his mark manipulating both time and image. In his award-winning 2000 Whitney Biennial piece, *Fragment of a Crucifixion (After Francis Bacon),* he appropriated a TV image of a basketball player in the middle of a game screaming in delight after scoring, and repeated it over and over while, at the same time, having digitally erased all other bodies from the court. The athlete, engulfed in the applause and shrieking of fans, looks grotesquely unhappy, as if caged in by his own success and objectification.

Long Count III (Thrilla in Manilla) (2001) zeroes in on another sporting event, in this case a boxing match. Pfeiffer masterfully erases the images of the boxers, but only to a certain point. The dimmest, ghostly outlines of the figures remain; the choreography of their movements is barely discernible. Pfeiffer cleverly and poignantly disembodies the brutality of the boxing match, which has the chilling effect of rendering the physical abuse all the more explicit through absence. Pfeiffer, as do others of his generation, especially Michal Rovner, uses digital postproduction techniques to maximize his artistic ends. In lesser hands, such tricks of the trade would be just that: tricks. But for Pfeiffer, these tools allow him to explore issues of identity, social prejudice, sports mania, and the ambiguity of images themselves.

For each of these artists, the digital revolution has rendered the image infinitely malleable. The art of photography, both still and moving, is forever changed. The challenge, however, remains the same: to tame the technology to serve a superior idea. The artists represented here do not merely enliven their still photography with moving-image photography. They apply the same conceptual rigor and crafted aesthetic to this very other (if complementary) medium. That their subjects dance, jump, or float is not what makes the video works important; it's that they do so in a framework that extends beyond the performance into the larger world of ideas — the place where all significant art dwells.

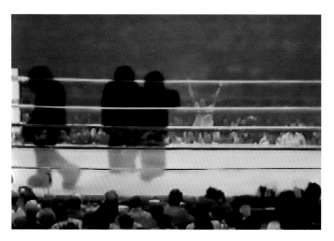

Paul Pfeiffer. *Long Count III (Thrilla in Manilla)*. 2001. LCD screen, DVD, mounting arm. Video: 3 min. 6 x 7 x 60". Collection Debra and Dennis Scholl

MICHAEL RUSH IS DIRECTOR OF THE PALM BEACH INSTITUTE OF CONTEMPORARY ART. HE IS THE AUTHOR OF *NEW MEDIA IN LATE 20TH-CENTURY ART* AND THE FORTHCOMING *VIDEO ART*, BOTH FROM THAMES AND HUDSON, AS WELL AS A CONTRIBUTOR TO THE *NEW YORK TIMES* AND *ART IN AMERICA*.

Notes

1. Martha Braun, *Picturing Time* (Chicago: University of Chicago Press, 1992), 234, 236.
2. In writing about artists who are now using a variety of moving-image media (video, digital video, film, including 8mm, 16mm, 35mm, etc.), often in combination, I find the designation "filmic artist" to be most useful. Referring to artists like Barney and Aitken, for example, as "video artists" is meaningless. See Michael Rush, "Eija-Liisa Ahtila," *Art in America* (Sept. 2000), 144.
3. Bonnie Clearwater, *Anna Gaskell*, exh. cat. (Miami: Museum of Contemporary Art, 1998), 4.

Imperfect Innocence

Gary Sangster: Can you characterize your collection?

Dennis Scholl: Our initial goal was to form a collection of contemporary photo-based art — not photography, but photo-based art. The work would be created contemporaneously with our acquiring it, making it art of our time, of *now*. The collection then grew to incorporate examples of a generation of immediate precursors, whose inclusion brought historical context to the current work we were focusing on. As the artists we were following began working in film and video, we moved the collection into these areas as well.

Gary: Why do you collect art?

Debra Sue Scholl: It is a way to live with visually intriguing and intellectually stimulating objects, and it is something that Dennis and I enjoy doing together. Unlike theater or concerts, visual art is something you can bring into your home and enjoy firsthand every day.

Dennis: I'm a compulsive, obsessive person, and collecting is one way of channeling that energy into a specific endeavor, creating some order in the world for myself. By focusing on a specific area and time frame, I gain a better understanding of the material and can make better choices. That sense of order comes only with a great deal of research — a lot of looking, talking, and reading. Debra's thought process and approach to collecting are quite different from mine, which contributes to the strength of the collection. The two of us together are much better collectors than either of us would be separately.

Anna Gaskell. *Untitled #97*. 1997–98. Ink on paper. 18 x 24".
Collection Debra and Dennis Scholl

Gary: Why do you think there are more people working in a photo-based way now than, say, ten years ago?

Debra: As image technology became more advanced, and at the same time less expensive, artists were intrigued by the expanded conceptual possibilities of manipulated imagery. The medium of photography was transformed, and artists responded with tremendous interest.

Gary: How did you get started collecting?

Dennis: Debra and I met the first day of law school in 1978. We became a couple almost immediately and art collectors soon thereafter. Our first important acquisition was a Robert Motherwell lithograph titled *Brushstroke* [1979], which we bought for $157 (after negotiating a $43 discount!). In order to feed our new art habit while we were in law school, we took jobs working at an art gallery in a shopping mall, the kind that sells paintings to match your sofa.

In no time, we had dozens of works by major graphic artists such as David Hockney, Roy Lichtenstein, Robert Longo, Elizabeth Murray, Robert Rauschenberg, James Rosenquist, and Susan Rothenberg. After about ten years, we had over two hundred pieces, so many that they began to take over our small home; they were stacked six deep against the wall. In 1987, we temporarily stopped collecting art and began buying and renovating Art Deco buildings in the South Beach section of Miami. That consumed all of our time, and money, for five years. In 1992, we started to think about collecting art again. We considered architectural drawings for a while, then African art, but in the end found our way back to the contemporary art auctions. In three consecutive sales we purchased photo-based work by Lorna Simpson, Barbara Kruger, and Bernd and Hilla Becher, respectively. At the time, we had little idea that the coming decade would be such a breakout period for the area we had defined as our collecting priority.

It's been said that once you have three of anything, it's a collection. Initially, we were concerned whether a photo-based collection might be too narrowly focused, running the risk of becoming an idiosyncratic exercise meaningful primarily to the collector. A collection that is too broad and unfocused, however, can appear to be an array of disconnected objects that do not resonate as a body of work. We discussed these ideas with a number of curators, including Bonnie Clearwater of the Museum of Contemporary Art in North Miami, who was particularly helpful and encouraged us to move forward with the photo-based focus.

Gary: How much do you rely on other people to animate the discussion of the collection?

Dennis: We engage other people to help us illuminate the meanings and effects of the artworks we have acquired. We seldom involve other people in making collecting decisions, trusting our own instincts and research. We're very organic about collecting; we see, we feel, we react, and we either buy or pass.

Gary: What are the exhibitions that have had the greatest influence on your collecting practices?

Dennis: The most important show was *Stills: Emerging Photography in the 1990s*, curated by Douglas Fogle at the Walker Art Center in 1997, which included the work of Julie Becker, Jeff Burton, Miles Coolidge, Thomas Demand, Anna Gaskell, Sharon Lockhart, and Sam Taylor-Wood. This exhibition was ahead of its time; it was as though Douglas could see the level of work some of these people were going to make in years to come. We were so impressed by the show that we supported its catalogue and acquired a number of works from it.

The first private photography collection we saw as an exhibition was that of Joseph and Elaine Monson of Seattle, when it was on tour in Portland, Maine, in 1996. Started earlier than ours, this collection showed us what it takes to create a significant holding of contemporary photography. The 1997 exhibition at The Museum of Modern Art, New York, *On the Edge: Contemporary Art from the Werner and Elaine Dannheisser Collection*, was a wonderful example of the model of focusing on a small number of great artists.

Gary: What kind of dialogue do you share with other collectors?

Dennis: We maintain a rich dialogue with collectors all over the world. We have five of the greatest collections in the world within five miles from our home — those of Irma and Norman Braman, Rosa and Carlos de la Cruz, Martin Margulies, Don and Mera Rubell, and Ruth and Richard Shack. Each of these collectors has had a particular impact on the way we collect.

Twenty years ago, when we first visited the Shacks' collection, they had art mounted to their bedroom ceiling because they had no more wall space. Seeing that was important for us because it suggested that there were no boundaries to collecting. Viewing Marty's sculpture garden in the '80s was liberating for the same reason. The Bramans taught us that one should acquire the best possible work within the level at which one collected, and the Rubells inspire us every day to be brave collectors, to reach for works and ideas that are challenging and fresh. After thirty-plus years of collecting, they are just as excited about an eight-by-ten-inch photo by a new young artist as they are about a large-scale acquisition by an established artist. The de la Cruzes helped us understand that as collectors our obligations extend beyond simply acquiring art for our own collection. They demonstrate a commitment to all aspects of patronage: buying pieces for museums, sponsoring shows, and helping artists realize expensive or difficult pieces. In essence, their message is that collecting is a privilege, and one should return something to the art world.

We discuss collecting ideas and emerging artists on a regular basis with Craig Robins and Estelle and Paul Berg, other great Miami collectors.

Beyond the local area, we have a network of collector friends all over the world who share new finds. We spend a lot of time talking about art in Aspen, Colorado, with some of the best contemporary art collectors in America, including Bob and Nancy Magoon, Stefan Edlis and Gael Neeson, Frannie Dittmer, Judy Neisser, Linda Pace, Toby Lewis, Bert Lies and Rosina Yue, Melva Bucksbaum and Ray Learsy, Kent and Vicki Logan, Arno and Danner Schefler, Harley Baldwin and Richard Edwards, Larry and Susan Marx, Bob and Linda Gersh, and Bill and

Maria Bell. They are all major art-world players who bring a lot to the dialogue on contemporary art.

Gary: Where do you get the best information about art, artists, and collecting?

Dennis: People ask us how we find new work so early, and the answer is that we put ourselves in front of lots of art, at many different venues. We make regular visits to New York galleries and studios, and travel to national and international art fairs and biennials. In many cases, artists make their purest work early in their career, during the period between art school and their first show. They generally have an idea they've been thinking about for a long time, and it is unsullied by critical reaction. As artists enter the art system and begin to respond to dealers and critics, the art can be in danger of becoming commodified.

We also look at a lot of second shows, because that is where you can tell if an artist has staying power. The second show is often the most important show of an artist's career.

Gary: How do you research and evaluate work?

Dennis: We are not impulsive buyers and prefer to do a lot of research about each artist. We like to compare examples we are considering with the artist's entire body of work, not so difficult when you collect artists early in their careers. We were the second people to buy Tacita Dean's work, after Charles Saatchi. We have Anna Gaskell *#1*, *#2*, and *#3* [1996] in our collection, Anna's first pieces. It is a thrill to find a young artist making extraordinary work. When we do, we try to start with a core group of objects and then add examples from each new body of work that she or he produces.

Gary: How important are the leading dealers in recognizing new talent and establishing what might be perceived as historical credentials?

Dennis: Galleries serve as the proving ground and are the best place to see new art. Sometimes we use dealers as a buffer, letting them sift through new work to find the people they are going to bring along and make an effort for. But we also buy a lot of pieces from artists before they are represented by dealers.

Gary: Even in the unrepresented work of an Anna Gaskell of six or seven years ago, there was an exhibition standard, or a "dealer quality," that distinguishes it from, say, the work of an Eva Hesse, which did not seem designed for the commercial network. Do you think artists are being implicitly trained to produce work for the art market?

Dennis: Photography by its nature can be manipulated to meet the highest standards of consumption. Over the last decade, the success of commercially motivated artists may have influenced other artists to create work that has that presentation quality. The best of contemporary photo-based work, however, is about the resonance of the image.

There is no escape from the economic and social pressures on artists, and this has always been the case. Though Hesse's work, because of its ephemeral nature, didn't have the dealer quality you speak of, she put herself into the critical mix, and to me that is the most important thing. It's crucial to have the work seen, and artists have to be aggressive about it.

Gary: In considering a prospective addition to the collection, how important are the visual or sensual qualities of a work in relation to its conceptual strategies?

Dennis: We always look for work that succeeds both on and below the surface, evoking a strong response, and not necessarily a positive one. For example, works by Zhang Huan or Catherine Opie invariably generate a reaction, but it is seldom one of pleasure. Many pieces in the collection carry a subversive message that sometimes emerges only with the "behind-the-scenes" story. In Douglas Gordon's piece *Three Inches (Black) #3* [1997], a dark finger reaches into vital organs like a knife. While it looks as though the finger was painted, in fact it was permanently tattooed black. This additional information brings a second level of discomfort, as one contemplates the pain of tattooing and the prospect of living with such a conspicuous body part for the rest of one's life. The depth of what Douglas was trying to convey seldom reaches the casual viewer.

Debra: Sometimes the works are so charged that they are too personalized by the spectator. We think this is particularly true for photography, as people tend to accept the veracity of a photograph, even where all indications are to the contrary.

Gary: Which tendencies in your collection do you find the most compelling?

Debra: One strong area is female portraiture, of a sort that defies the usual conventions. Some examples are Janine Antoni's image of her hands, in which her fingernails seem to have grown together (she used press-on nails); Rineke Dijkstra's depictions of herself and a girl clenching her toes; Naomi Fisher's body interacting with nature; Anna Gaskell's women involved in a dark, fairy-talelike story; Katy Grannan's and Thomas Ruff's exposure of body and face, respectively; Hellen van Meene's young girl pinching herself until she is black and blue; Catherine Opie's picture of herself cutting a scene into her own back; and Bettina von Zwehl's girls forced to pose after being woken up in the middle of the night.

Gary: How do you respond to the fact that the cutting-edge work you collect is unacceptable to many people?

Dennis: We see our role as twofold. One is to promote the highest-quality art that can be made in the contemporary art world, and the other is to pursue a kind of a missionary function. We want to get more people involved in this process, because there are a

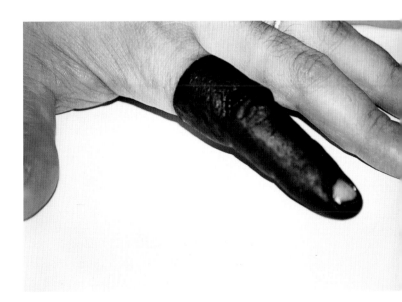

Douglas Gordon. *Three Inches (Black) #3*. 1997. C-print on paper. 31¾ x 41½". Collection Debra and Dennis Scholl

lot more artists than there are patrons. Many people are interested, but they are intimidated by their lack of background and uncertainty about what they're looking at. If you bring them along to become excited by the challenge of engaging with difficult work, they may ultimately become new collectors themselves, and that is what the art community needs.

Gary: Have you influenced others in their approach to collecting and displaying art?

Dennis: We may have influenced other collectors in a small way by opening our home to so many visitors. This responsibility is critical to the many young artists in the collection, who may not have work on view in a gallery or museum at any given moment. Over the last few years, more than two thousand visitors have come to view the collection, including many curators and collectors, several of whom have pursued the work of artists they first saw in our home.

Gary: How has the concept of patronage evolved to meet the needs of the present cultural economy?

Dennis: I think that the concept of contemporary art has been distributed to an increasingly broad base. During the past couple of decades, individuals have become more actively involved in the arts at a more participatory level, in part to compensate for the diminished role of institutions and the government agencies that support them. The cultural institution is no longer the place where you go to see what is new; it has become a validating mechanism rather than a creative force. I also think that artists lurk outside the system a lot more, unless or until, of course, they are absorbed or seduced by it. I love to look for the subversive message of artists who challenge the establishment.

Gary: Do you think that institutions were ever created for artists?

Dennis: During the 1970s, with the Minimalists and the body artists, things were happening in the institutions that were much closer to the time and spirit of creation. I think the idea of the blockbuster show has contributed to the dramatic change in the behavior of

institutions. Museums have to plan two or three years in advance, and there is less room in their schedules for experiment and happy accidents.

Gary: How do you think that the blockbuster exhibition has affected the production and reception of contemporary art?

Dennis: The market effect of blockbusters, from Tutankhamen's treasures to Jackie Onassis's couture, has put a lot of pressure on institutions to allocate their budgets and time to shows that are economically successful and very, very popular. There are some institutions, especially in Europe, that don't, or won't, do that. The European model of the Kunsthalle provides experiences rarely found in U.S. museums. In the States, the blockbuster has generated more funds and a wider range of audience for the museum, but it has supplanted shows that are edgier and more challenging.

Gary: What role do you think education has played in the expansion of the art world in general, especially in photography?

Dennis: Our only relevant experience has been our collecting out of the Yale University M.F.A. program in photography, in which Gregory Crewdson has taught. We fell into that in the mid-'90s, when Gregory was hitting his peak as a teacher. The students were exceptional photographers.

Gary: What do think is the driving impulse that makes the work that came out of Yale, particularly by the women you have supported, so successful?

Dennis: For me, it was the notion of the tableau, which emerged in Crewdson's early work. Looking at the photographs, you don't necessarily know that in most cases, the people are actors, the sets are staged. The predominantly women artists who came out of the program expanded on the idea, designing elaborate costumes and sets, even conducting casting calls. The pieces, which look like Hollywood production stills, are original and, at times, scary as hell. Of course, the precursor here is Cindy Sherman. Her influence on this group of artists is pervasive.

Gary: What do you mean by "scary as hell"?

Dennis: In Anna Gaskell's early work, such as the *wonder* series [1996] and *override* [1997], young women, all wearing the same type of costume, reach out to push and pull each other in an ambiguous drama of love, lust, or perhaps hate. The pictures are framed in such a way that you can't center yourself in relation to the scene they present. They are frightening. To capture raw emotion on a piece of film or a piece of paper without its becoming kitschy or clichéd is a difficult thing to do. We found the way she was able to finesse this to be one of the most interesting aspects of the work.

Gary: How do people who see your collection respond to this degree of psychological pressure?

Debra: Usually, people who are not involved in the art world are either appalled or disgusted. There are some who find certain works, for example, by Hellen van Meene or Nan Goldin, visually stunning initially, and then, when they absorb its implications, are repelled, incredulous that we would live with something like that in our home.

Gary: What do you say to those people?

Debra: I believe everybody is entitled to his or her own opinion, which is what art is about. If someone has a strong reaction to a piece, whether they like it or not, I think that's great. If a work in our home doesn't move or provoke anyone one way or another, I don't consider it a success.

Gary: What are the reactions to the cooler, more cerebral work in the collection?

Dennis: When we show the collection to people who don't know anything about conceptual art, we spend time trying to give them a bit of the "back story," as I call it. Sometimes, their eyes glaze over, and we move on. At other times, they become engaged and we get wonderful responses. They look at the Bechers, and then look at Candida Höfer, and see the connections and influences. Some people make the leaps quickly, having walked through the collection only once, while others never do. Some fifteen hundred people will see

the collection this year; if fifteen of them go out and buy a piece of new art, we've done a wonderful job.

Gary: What are the differences between seeing a work in a domestic setting and in a museum or gallery?

Dennis: Showing art in our home creates a sense of intimacy. People feel more comfortable coming up to a piece and studying it for a prolonged period of time than they would in a museum or gallery. The intimacy leads to knowledge, and knowledge creates a feeling of appropriation. You take the art with you in a sense.

Gary: What is your process for rotating your collection?

Dennis: Initially, because we were so inexperienced in displaying art, no matter what we did the collection

Cindy Sherman. *Untitled #112*. 1982. Color photograph. 45 ½ x 30". Collection Solomon R. Guggenheim Museum, New York

never looked as good as exhibitions we saw in museums. So about five years ago we asked our friend Casey Kaplan, a gallerist from New York, to install it. The results were amazing. After a year, we had it reinstalled by Douglas Fogle of the Walker Art Center. This time, we vacated our home for three days, leaving Douglas free to completely redesign the installation, and provided him with several assistants to hang it. We've repeated this process on an annual basis, with the team of Matthew Drutt of The Menil Collection and Claudia Schmuckli of The Museum of Modern Art, followed by Connie Butler of the Museum of Contemporary Art in Los Angeles, and recently Rochelle Steiner of the Serpentine Gallery in London.

The rewards are obvious. These are all young curators, specialists in their fields, intimately familiar with the type of cutting-edge work in our collection. Each installation has exposed the work to us in a new way, with unexpected juxtapositions that we would never have achieved had we not given up control over the process. So far, each curator has approached the task very seriously, recognizing that many of his or her peers and mentors may well see and evaluate the results over the following year. The curator writes a brief introduction to the installation, describing his or her decision-making process and objectives for each room.

There are risks involved for us in this approach. There is space for only about 25 percent of the collection to be hung each year, so the curatorial selection has to be rigorous. We make a commitment to live with the installation for a year regardless of whether or not it meets our expectations (fortunately, the results have been fantastic thus far). The other risk concerns the independent review of our collecting decisions. If some works you believe to be significant to your collection are ignored year after year by the curators, it causes you to reflect on your judgments. But we believe that kind of self-reflection, combined with external validation or skepticism, serves to make us more effective and discerning collectors.

Gary: How do you handle large-scale works designed for a museum context in the constrained conditions of a home?

Debra: We make sure that our larger-scale pieces are shown appropriately — we avoid forcing them on a wall that is too small. We have torn out our fireplace in order to hang art; we have moved walls in order to hang art; we have given up bookcases in order to hang art. We don't install work salon style, and we don't try to force art where it won't go. If something doesn't fit immediately, we wait until next year, and see if we can find room for it then.

Gary: What is your relationship to institutions and your involvement with museums?

Debra: We've always been active with institutions. When we started collecting, Dennis was involved with the Museum of Contemporary Art in North Miami, where he served on the executive committee of the board of trustees. Other institutions we support in Miami include the Miami Art Museum and a young alternative space called Locust Projects.

Dennis: On the international level, we participated in the founding of the Guggenheim's photography committee; [Dennis] was founding chairman for three years, and we remain members of the committee. Nick Serota, director of the Tate, then approached us about starting an American acquisition committee for the Tate Modern in London. The Tate has the largest collection of American art outside of America, but because of budget freezes, the staff had purchased very few works by American artists and relied primarily on donations. We felt it was important to the artists we were interested in that we participate, and have spent considerable time working with the curators there since the group was founded about a year and a half ago. In Colorado, we are on the National Council of the Aspen Art Museum, and have helped fund shows by Anna Gaskell and Thomas Demand there.

Gary: Do you get involved with institutions on account of the artists or the institution, or both?

Debra: We consider supporting a museum if we are interested in the artist it is showing or the curator who has organized the presentation, and we try to help both of them by contributing to a catalogue or offsetting the exhibition expenses.

Dennis: There are a number of curators with their fingers on the pulse of what's going on, who drive the contemporary dialogue, and these are people we like to help and spend time with. We sponsor shows and catalogues for places like the Walker Art Center, for which we have also acquired art, the Museum of Contemporary Art in Chicago, where we worked with a great young curator, Dominic Molon, and the Hammer Museum at UCLA in Los Angeles; we helped produce a catalogue on the work of Dara Friedman for SITE Santa Fe.

Gary: Most collectors get involved only with organizations or institutions with which they have some kind of geographical relationship. What you're doing is unusual in that your support is being driven by relationships with artists.

Dennis: Our collection is international, and that makes the difference. We live in a place where the work does not necessarily come to us. Although Miami Beach is becoming more artistically vital, with a wonderful local artist colony, the recent art fair organized by Art

Basel, and a number of great museums, it is not a hotbed of contemporary conceptual art activity. We spend a lot of time interacting with people in Venice, Kassel, Basel, London, New York, Los Angeles, and Paris. We work with that thin slice of the art world that is committed to cutting-edge art and is involved with the museums, Kunsthalles, and alternative spaces that are showing it, and the dealers and collectors who support it.

Gary: How do you determine when it is appropriate for you to lend a work to a particular exhibition or project? Do you have specific criteria?

Dennis: If an artist says, "I've been invited to be in a show, and it's really important to me that you lend your piece," we cooperate without fail, even if we would prefer not to lend a work due to its fragility. On other occasions, we make our decision based on the quality of the curatorial idea, the context in which our work will be presented — with which other artists and works — and the history of exhibitions at that location.

Dining room of Debra and Dennis Scholl, curated by Connie Butler, 2001

Gary: Have you lost interest in any of the pieces you have lived with?

Debra: I don't think you ever grow tired of excellent work. Recent acquisitions may be a little fresher for you than pieces you've owned longer and are more familiar with, but all good art withstands repeated viewing. When we change installations and see works in new contexts, we look at them with renewed interest.

Gary: Does the meaning of the work change for you as you experience it over time?

Debra: It does. There are times you buy a piece for a particular reason, and then years later you see something quite different in it. Perhaps the artist's reputation, or the role of that kind of work in the art world, has changed, or your own relationship to the piece has deepened as time has gone by.

Gary: Can you give me a specific example?

Debra: Although we looked closely at the work of Gordon Matta-Clark for many years and knew a great deal about it, I never really understood his impact on the art community. Now that we have some of his work and I can see it in relation to other parts of our collection, I understand in a much clearer way his importance to the younger artists who have studied and absorbed his projects and pieces.

Gary: Given that the collection could be considered a compendium from a particular time, place, and perspective, how do you feel it will be received by future audiences?

Dennis: Because the collection is not a public archive, or accessible within a museum, we are less concerned about fluctuating tastes and standards of quality than an institution would be. Our goal is to capture a moment in time. Few artworks become iconic images that transcend their moment in history. We know that, whatever our aspirations, all the pieces in the collection will not be of equal importance in ten or twenty years. However, the collection as a whole will constitute a representative sampling of what contemporary artists were doing with photography from about 1992 onward, and whom they were looking to in the preceding generation of artists concerned with the capabilities of photographic representation.

To us, the collection is like a living organism, always morphing into something new. Seeking and finding creative, challenging work is thrilling for us. Both the process of collecting and the collection itself give us great pleasure, and for that we are extremely grateful to the artists.

SELECTIONS FROM THE COLLECTION

Amy Adler *Once in Love with Amy* 1997. Cibachrome. 50 x 34"

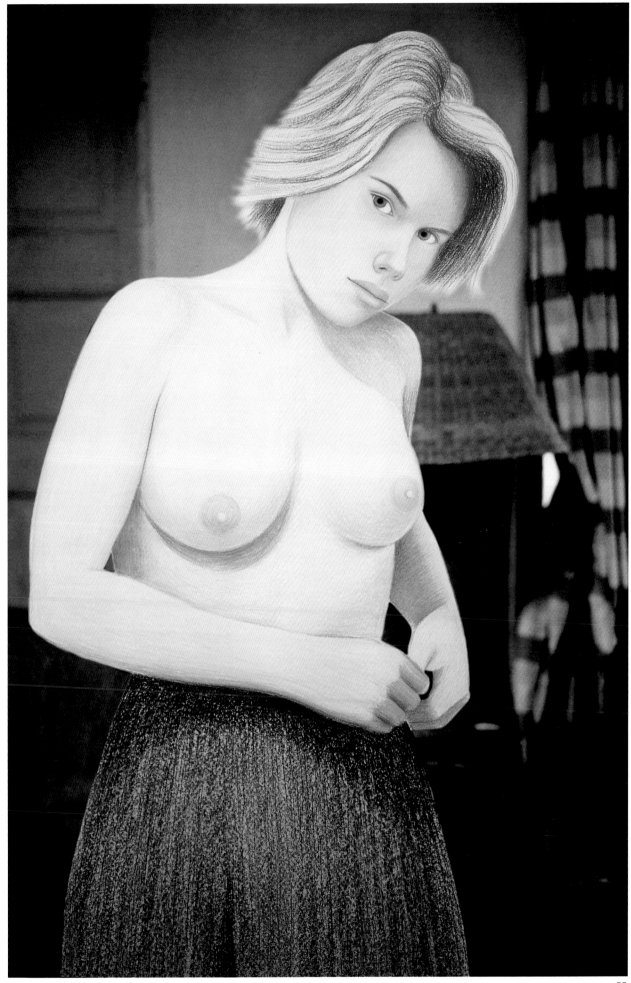

Doug Aitken *Passenger* 1997. Cibachrome laminated to Plexiglas. 39 x 48"

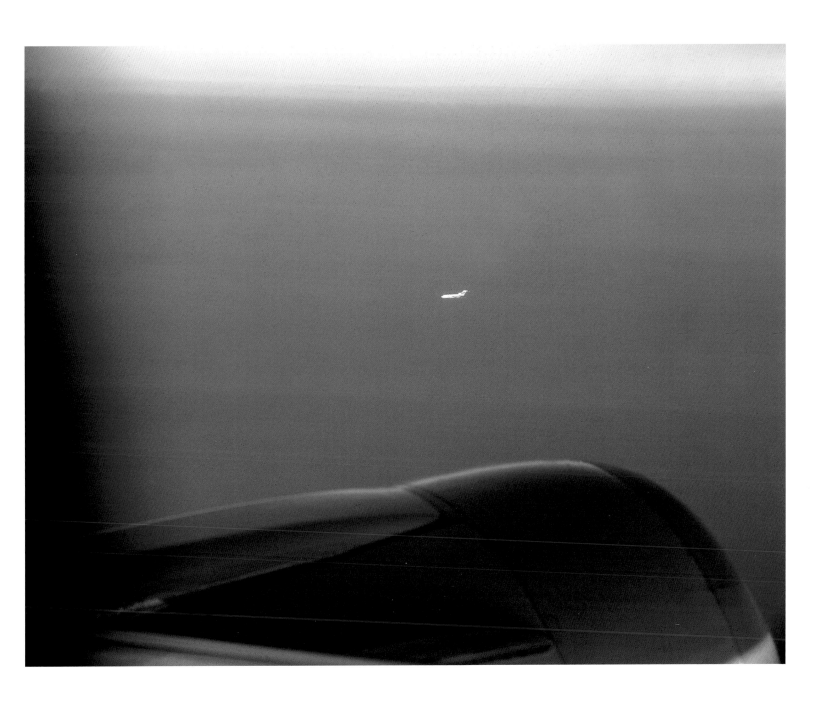

Doug Aitken *The Mirror #11 (Rise)* 1998. Cibachrome laminated to Plexiglas. 30 x 35"

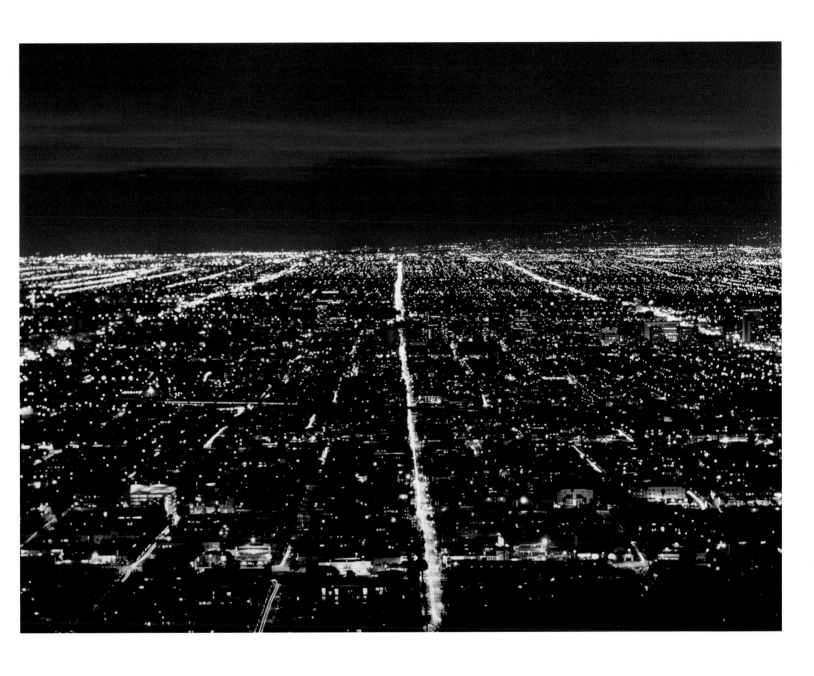

Janine Antoni *Ingrown* 1998. C-print. 18 1/8 x 16 5/16"

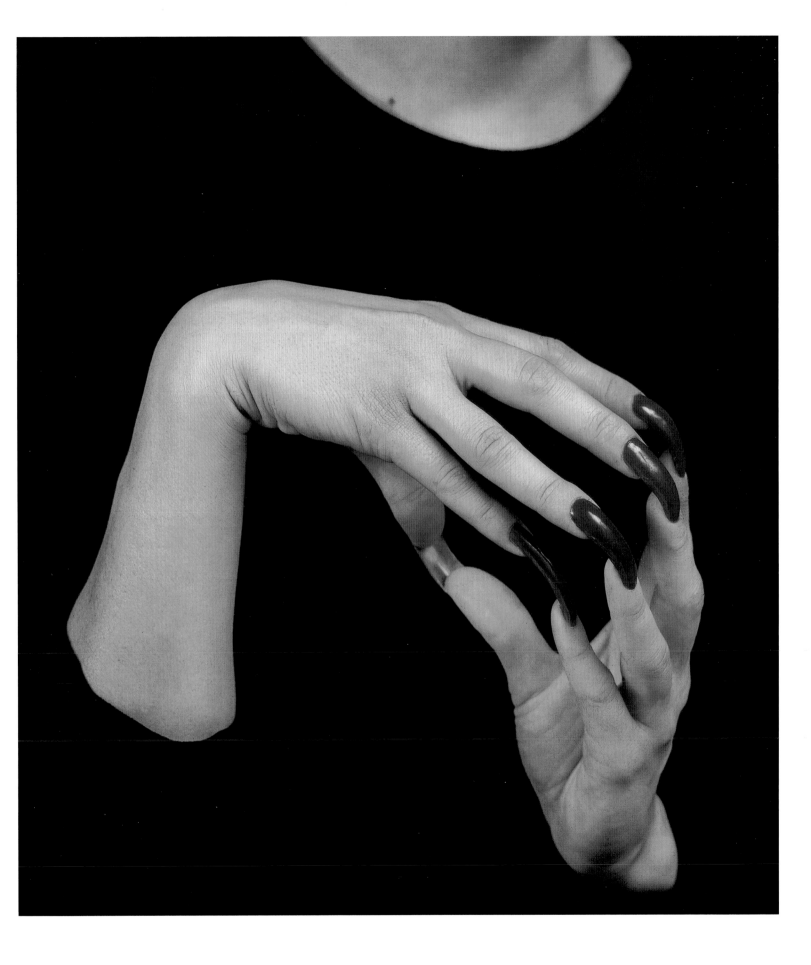

John Baldessari *The Fallen Easel* 1988. Lithograph with silkscreen on paper and metal. 74 x 95"

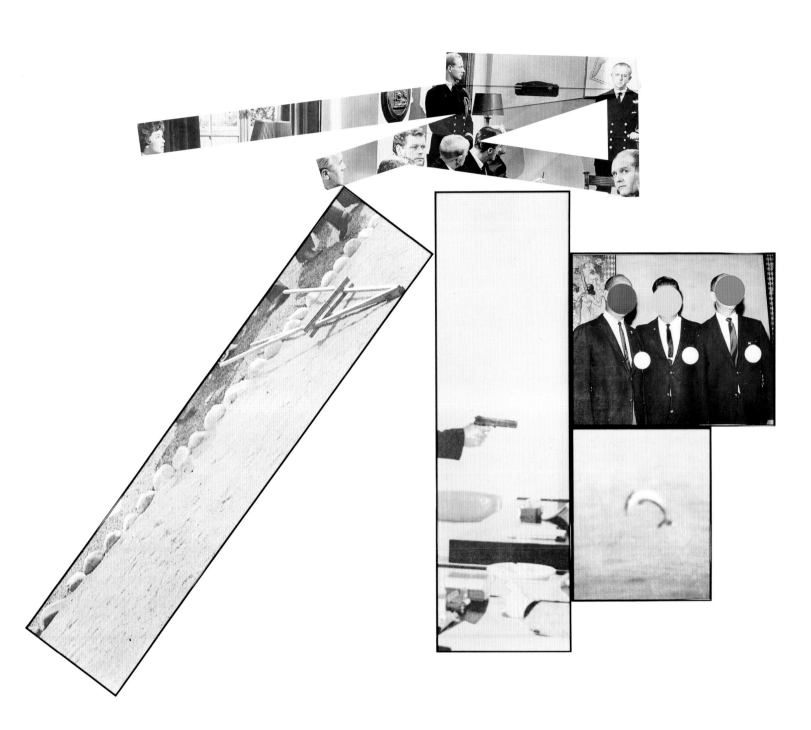

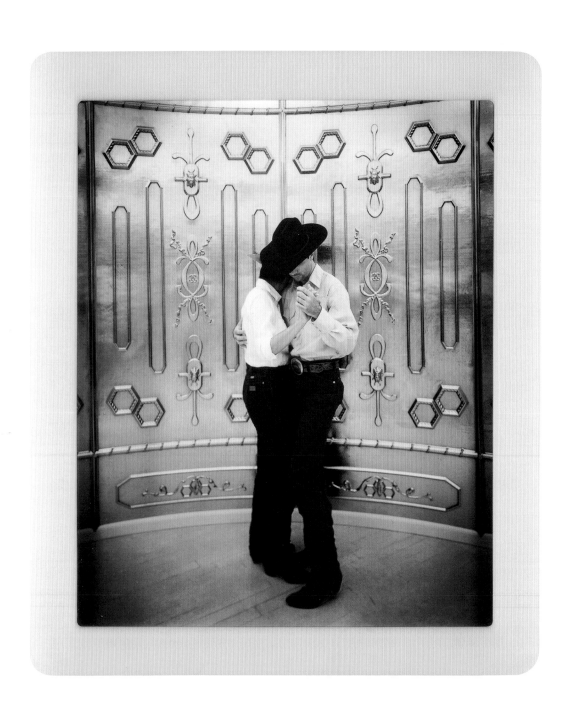

Matthew Barney *Cremaster 2: The Executioner's Song* 1998. Laminated C-print in acrylic frame. 28 x 24"

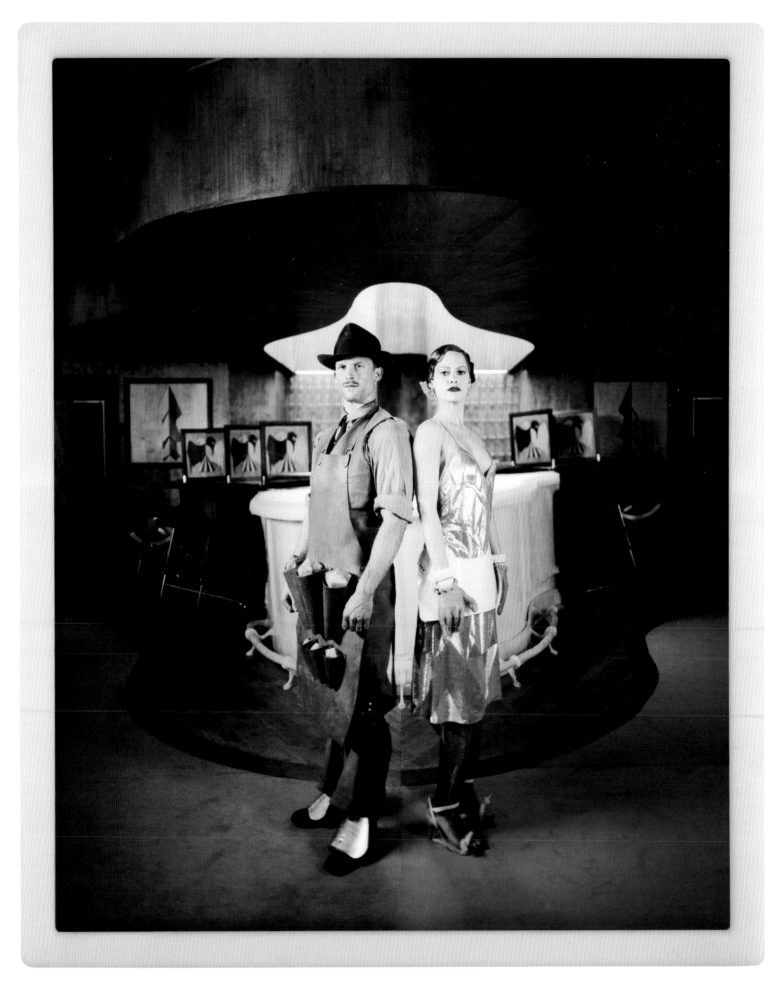

Matthew Barney *Cremaster 3: Plumb Line* 2001. C-print in acrylic frame. 54 x 44"

Uta Barth *Field #7* 1995. Color photograph on panel. 23 x 28 ¾"

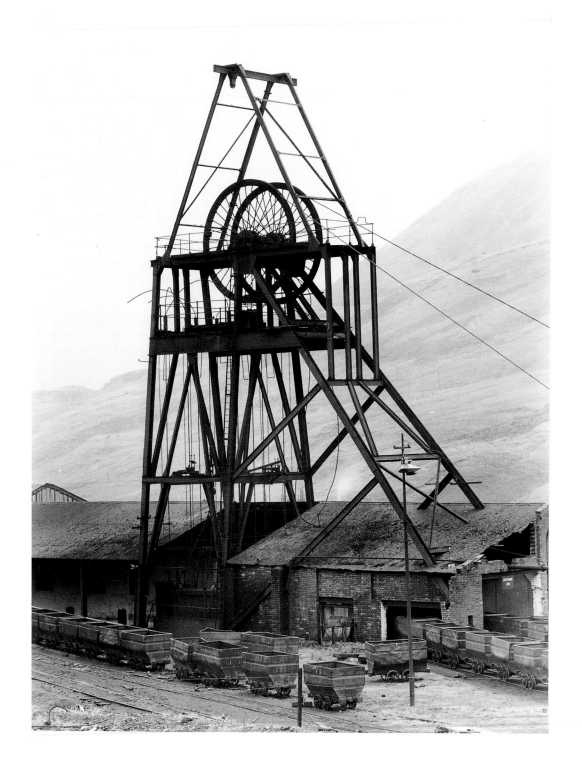

Bernd and Hilla Becher *Pithead No. 6 and 32, Glen Rhondda Colliery, Treherbert, South Wales* 1966.
Framed black-and-white photographs. 12 ½ x 12 ¾" each

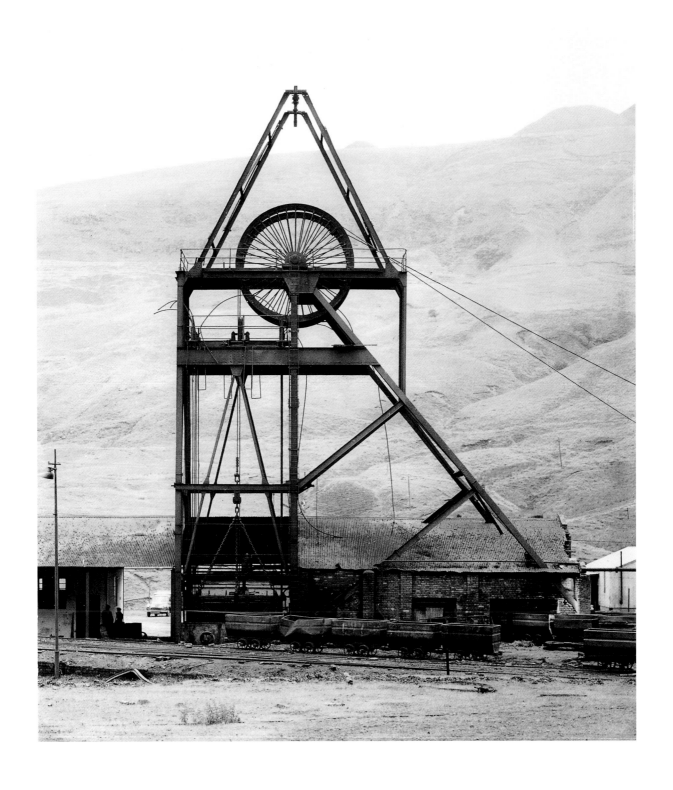

Jeff Burton *Untitled #26 (Black Couch)* 1995. C-print. 30 x 40"

Jeff Burton *Untitled #37* 1996. C-print. 30 x 40"

Miles Coolidge *L.A. Museum of Natural History* 1993. C-print. 39 x 29"

Miles Coolidge *606 South Olive Street* 1993. C-print. 39 x 29"

John Coplans *Self-Portrait (Feet, Frontal)* 1984. Gelatin silver print. 31 ½ x 24"

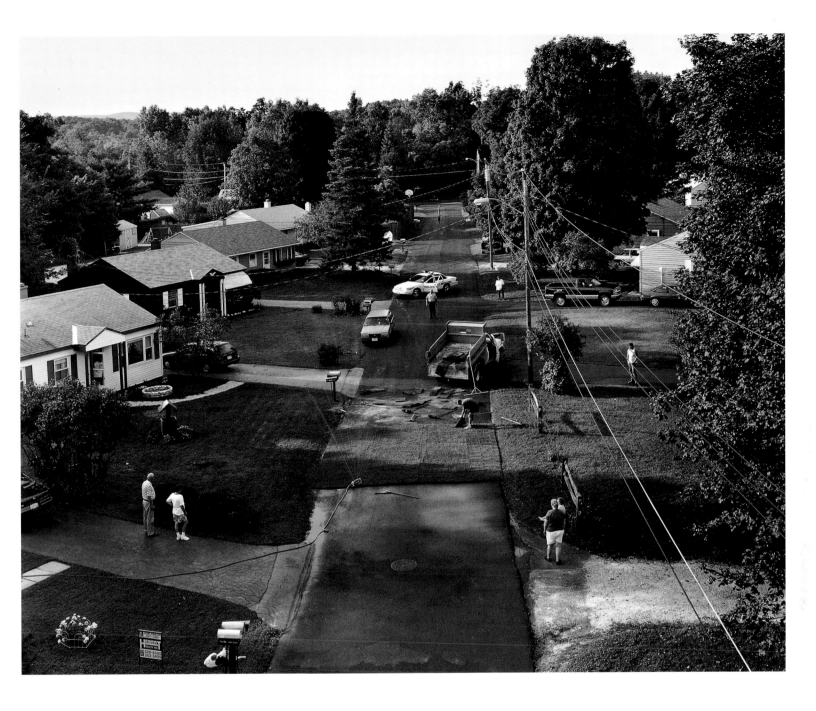

Gregory Crewdson *Untitled* 1997. Gelatin silver print. 20 x 24"

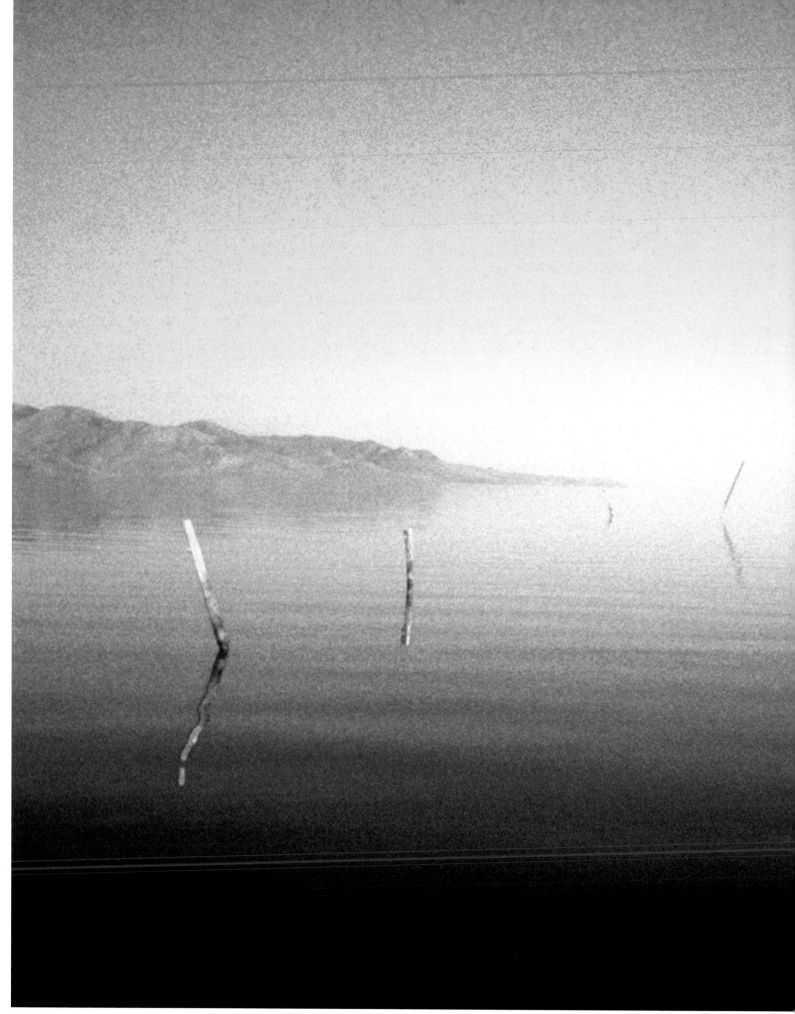

Tacita Dean *Rozell Point* 1999. 35mm slide projection. 58 x 75"

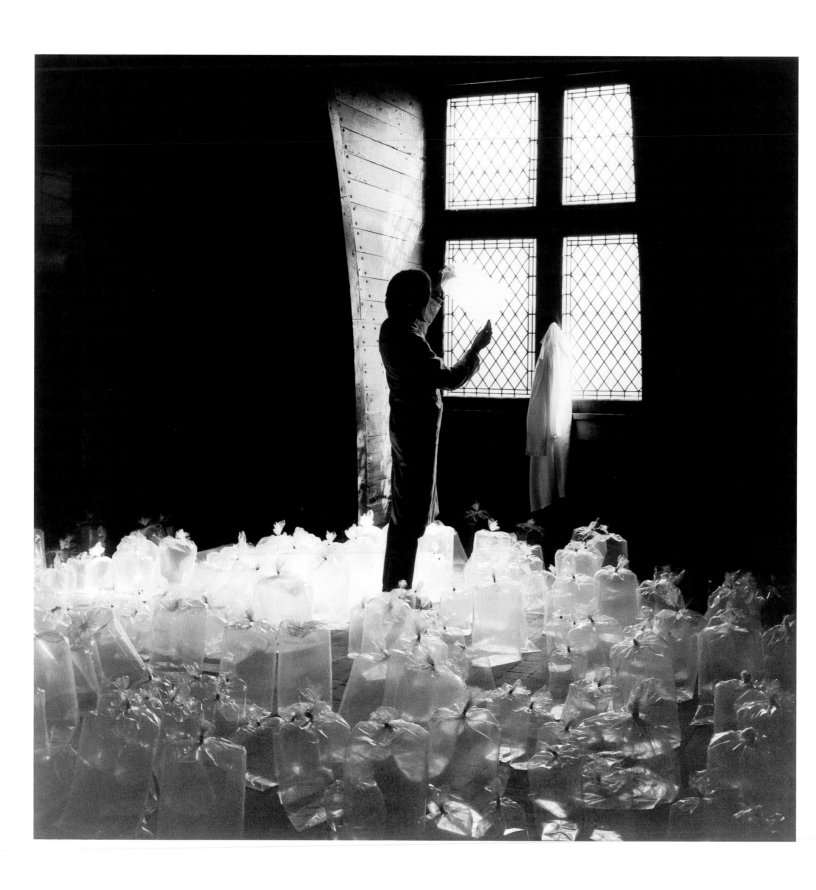

Tacita Dean *Palais Jacques Coeur* 1995. R-type photograph. 31½ x 31½"

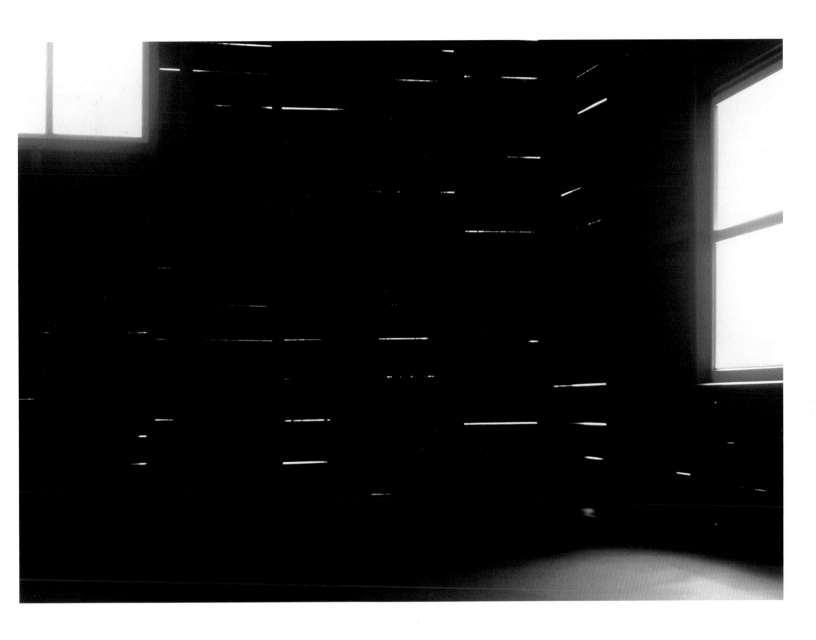

Thomas Demand *Scheune (Barn)* 1997. Chromogenic print on photographic paper Diasec. 72 x 100"

Thomas Demand *Labor* 2000. Chromogenic print on photographic paper Diasec. 71 x 105½" 62

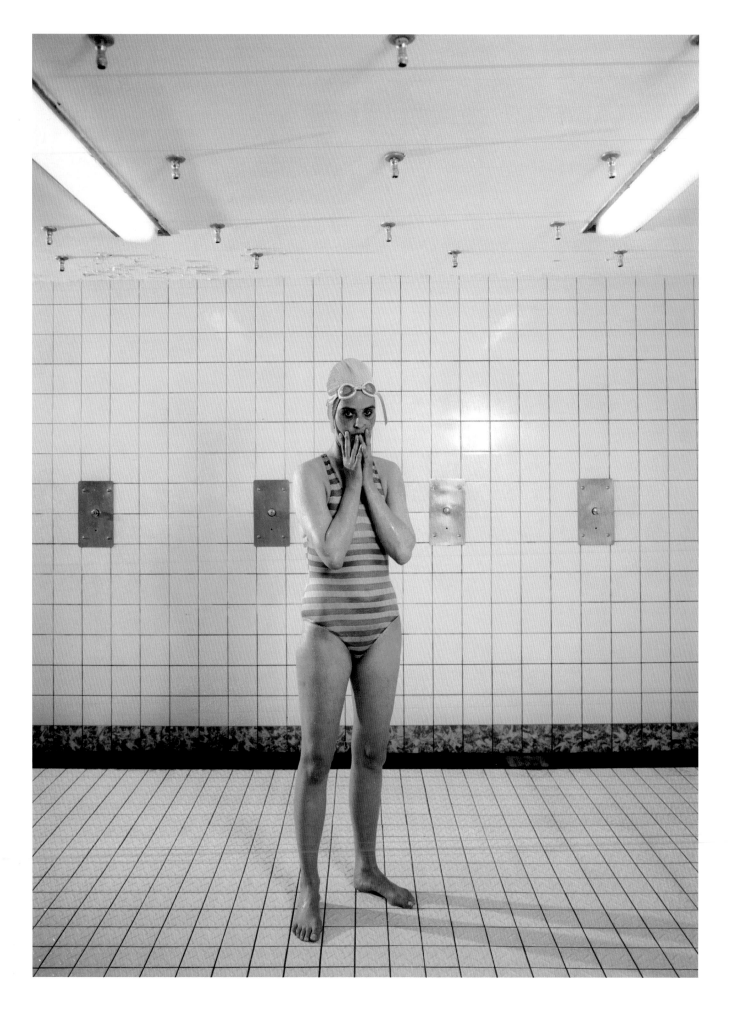

Rineke Dijkstra *Self Portrait, Marnixbad, Amsterdam, NL, June 19th, 1991* 1991. C-print. 24 ⅜ x 20 ½"

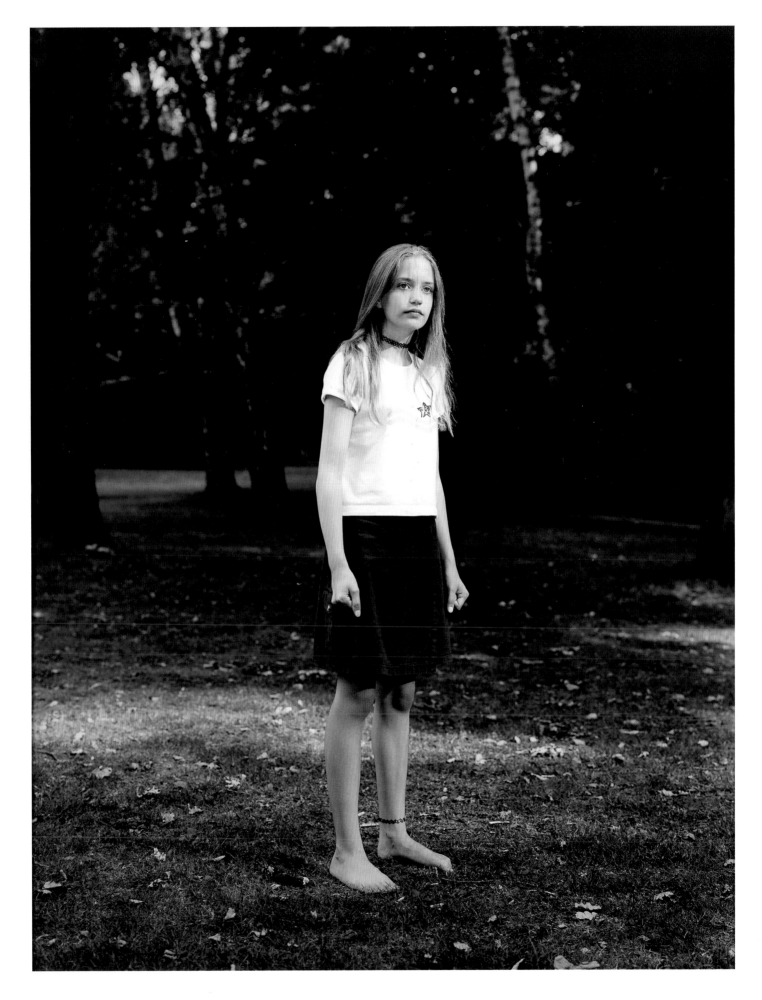

Rineke Dijkstra *Tiergarten, Berlin, Germany, June 27, 1999* 1999. C-print. 57 x 45"

Willie Doherty *Factory II* 1994. Cibachrome on aluminum. 48 x 72"

Willie Doherty *Suspicious Vehicle* 1995. Cibachrome on aluminum. 48 x 72"

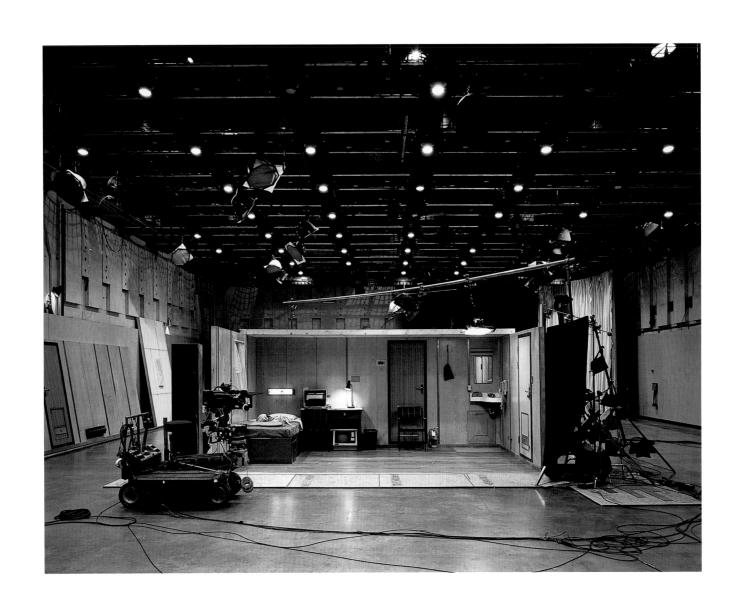

Stan Douglas *Journey into Fear: Pilot's Quarters 1 and 2* C-print. Diptych, 48 x 106" overall

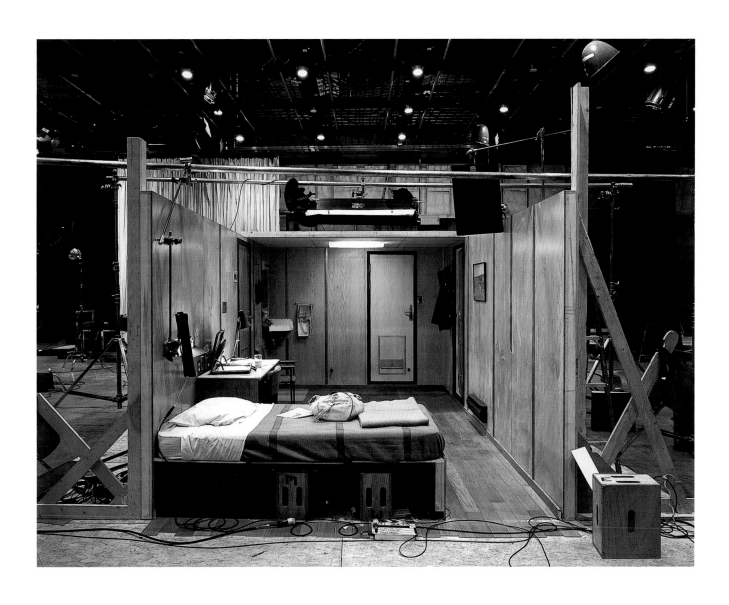

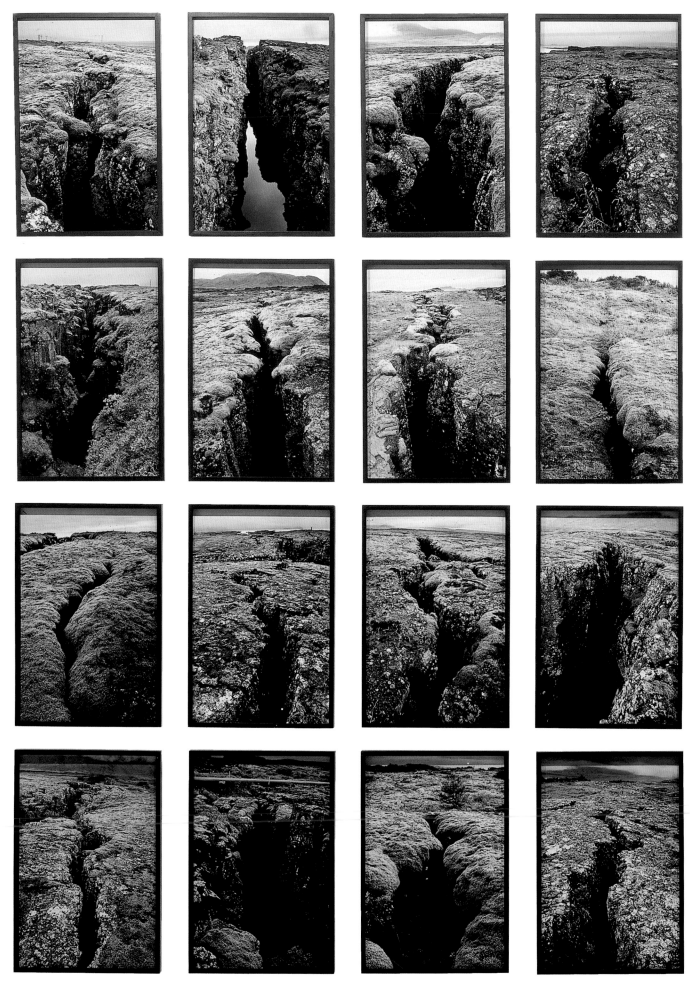

Olafur Eliasson *The Fault Series* 2001. Framed color photographs. 103 ½ x 146" overall

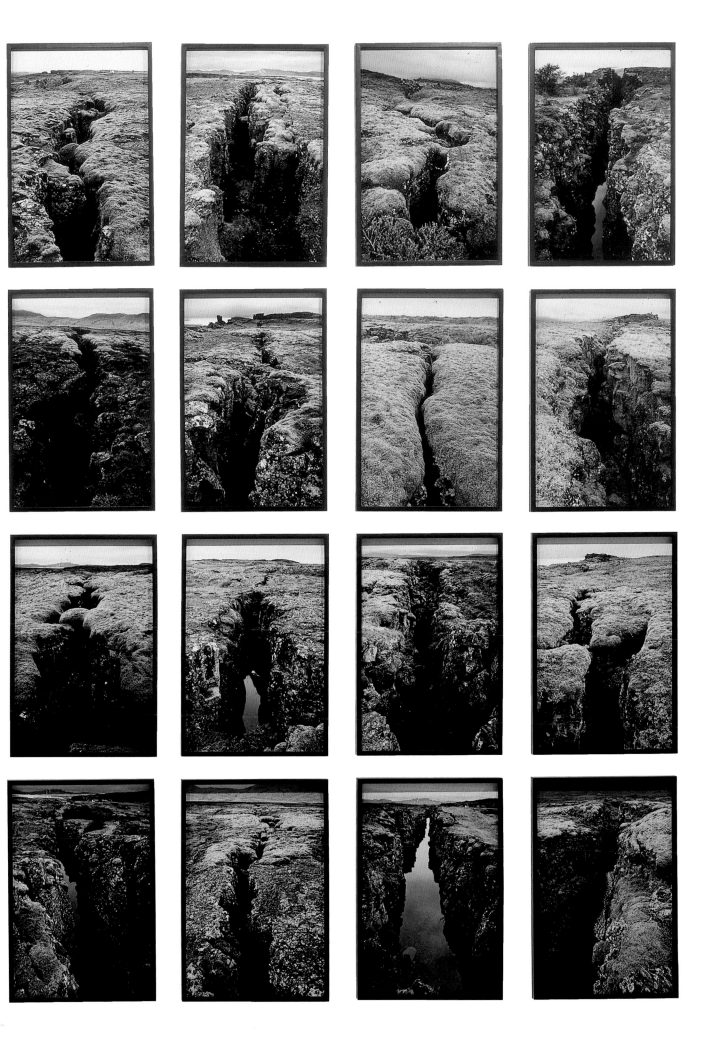

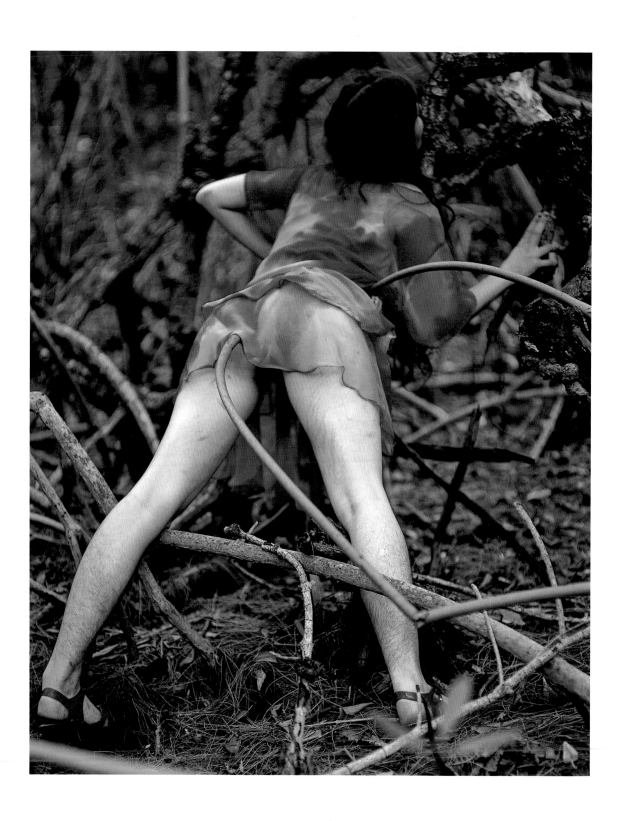

Naomi Fisher *Untitled (Orange Dress)* 1997. Cibachrome. 26 x 20"

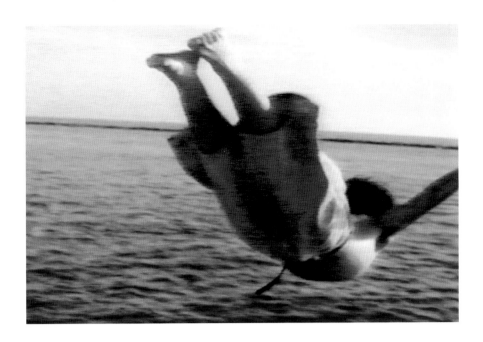

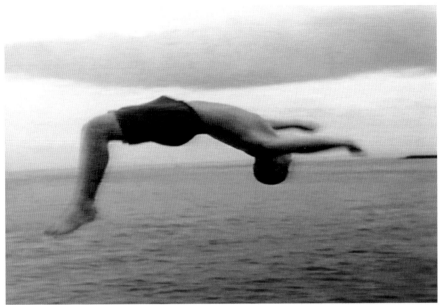

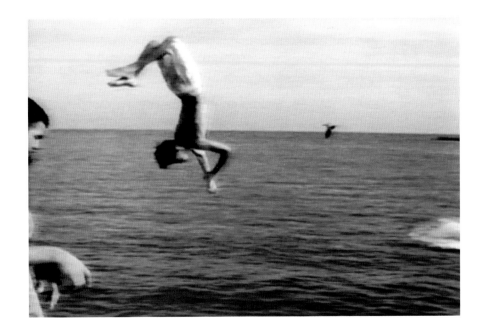

Dara Friedman *Government Cut Freestyle* 1998. Silent film loop transferred to DVD. 9 min., 20 sec.

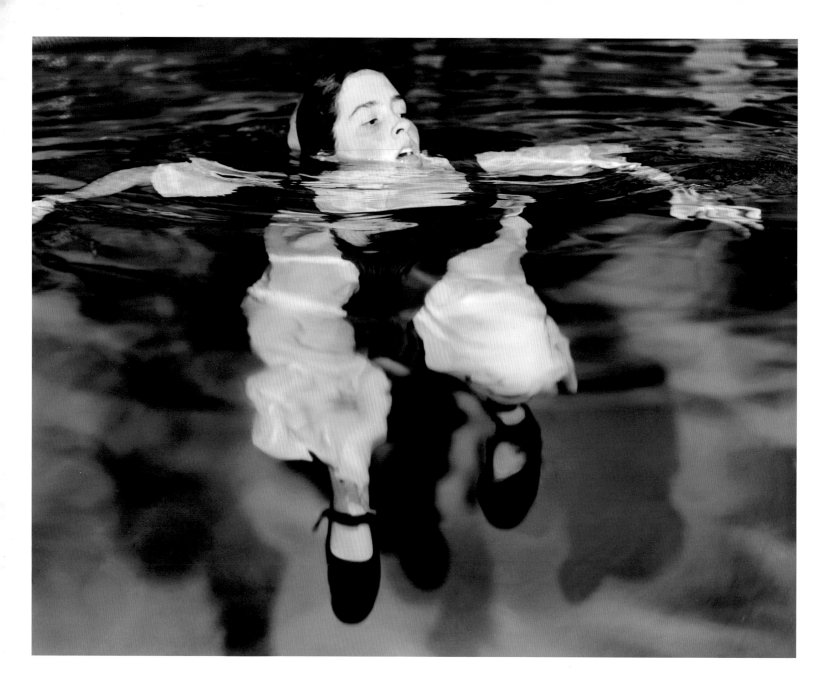

Anna Gaskell *Untitled #1 (wonder)* 1996. C-print. 16 x 20"

Anna Gaskell *Untitled #31 (hide)* 1998. C-print. 70 x 60"

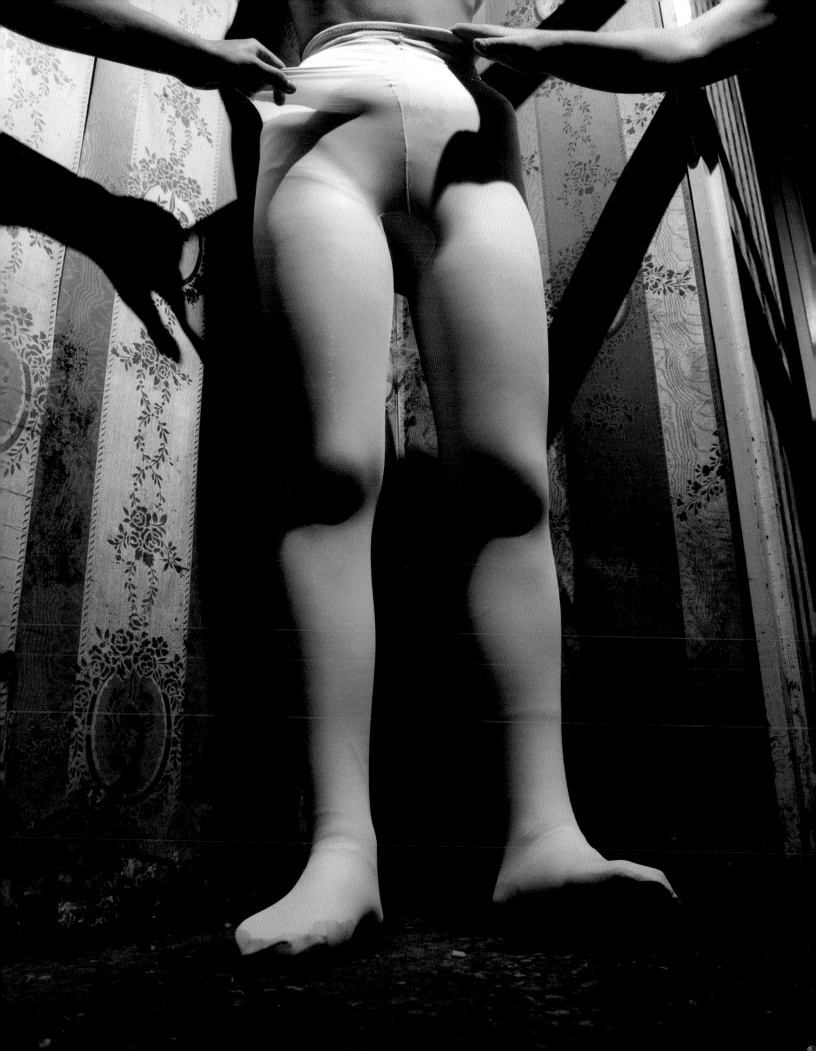

Anna Gaskell *Untitled #58 (by proxy)* 1999. C-print. 60 x 70"

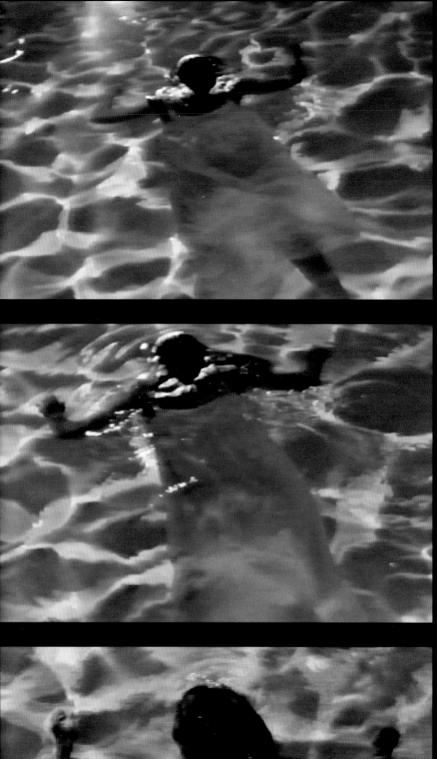

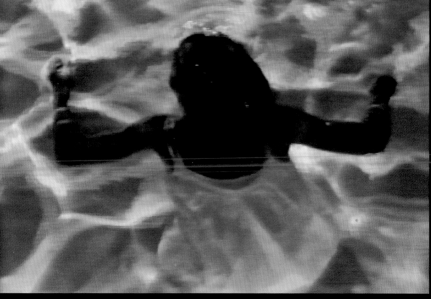

Anna Gaskell *floater* 1997, 16mm color film transferred to DVD, 1 m

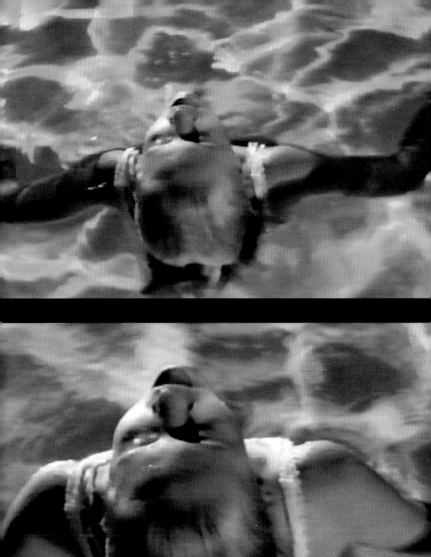
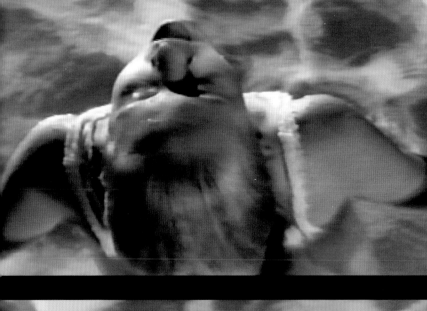

Robert Gober *Newspaper* 1992. Photolithography on Mohawk Super Fine archival paper, twine. 11 x 13 x 5"

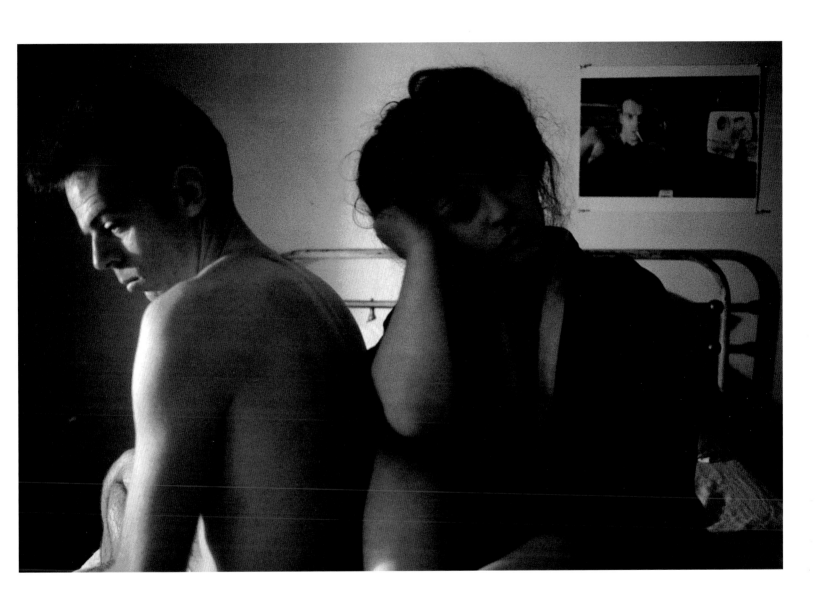

Nan Goldin *Nan in Kimono with Brian* 1983. Cibachrome. 20 x 24"

Douglas Gordon *Three Inches (Black) #3* 1997. C-print on paper. 31¾ x 41½"

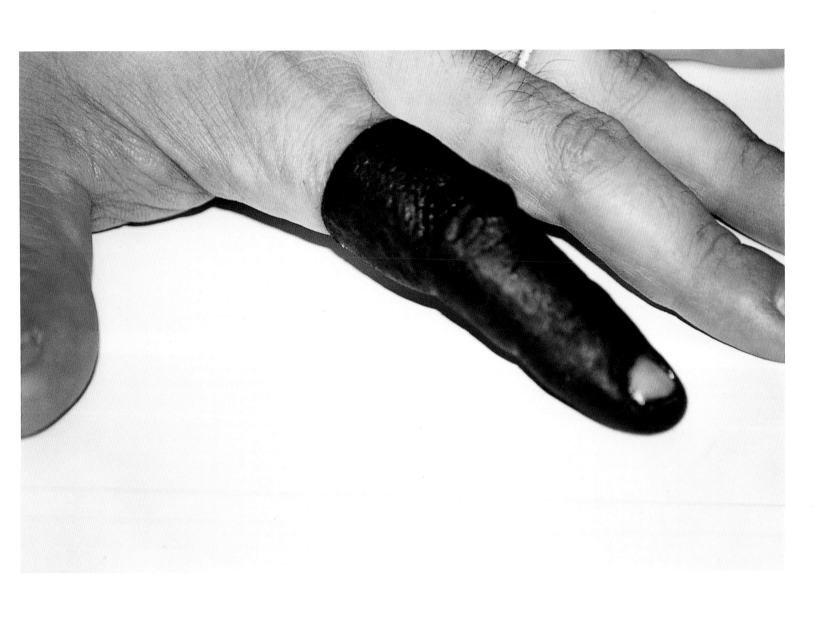

Dan Graham *New Houses behind Chain Link Fence, Jersey City, N.J.* 1966. Color photograph. 26 ½ x 22 ½"

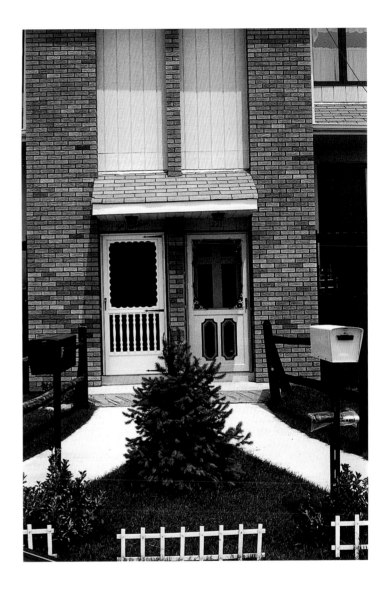

Dan Graham *Housing Project, Staten Island, N.Y., 1974, 212–221, Two Home House Entrance, Staten Island, N.Y., 1976*
1974–76. Color photographs. 25 x 34 ½" overall

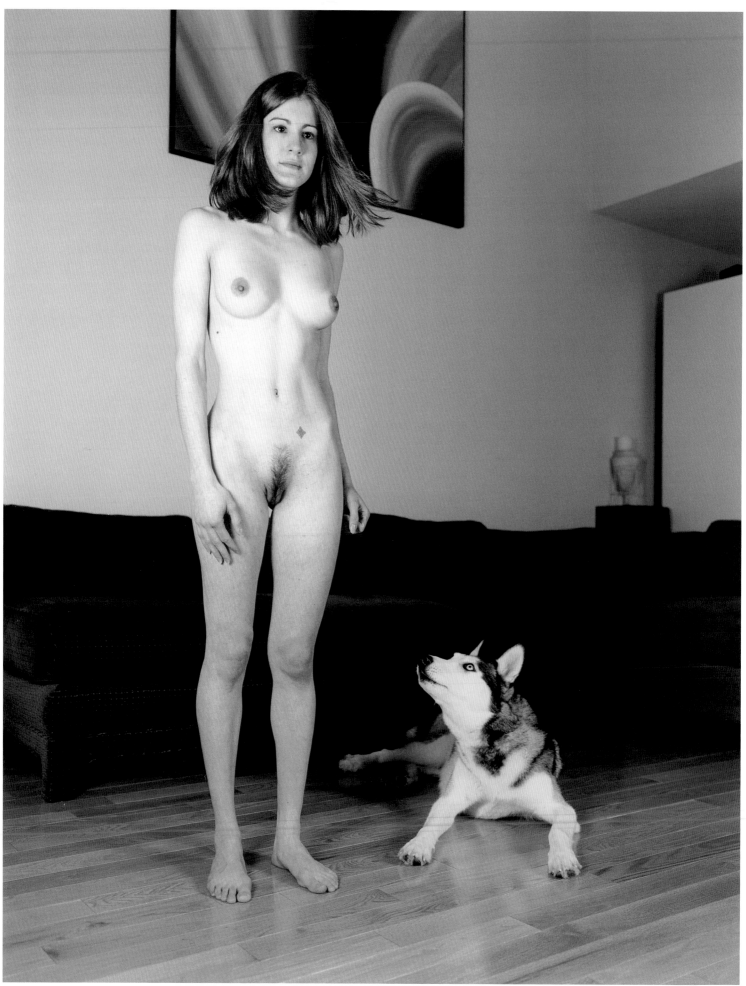

Katy Grannan *Untitled (from the "Poughkeepsie Journal")* 1998. C-print. 45 x 35½"

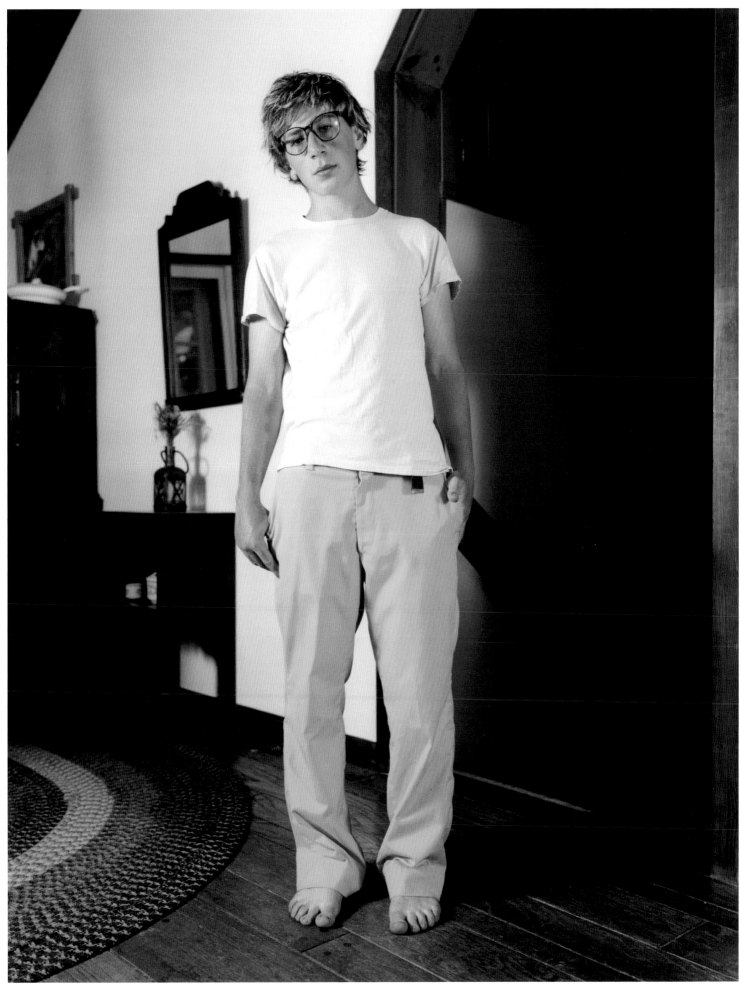

Katy Grannan *Rhinebeck, New York* 2000. C-print. 45 x 35½"

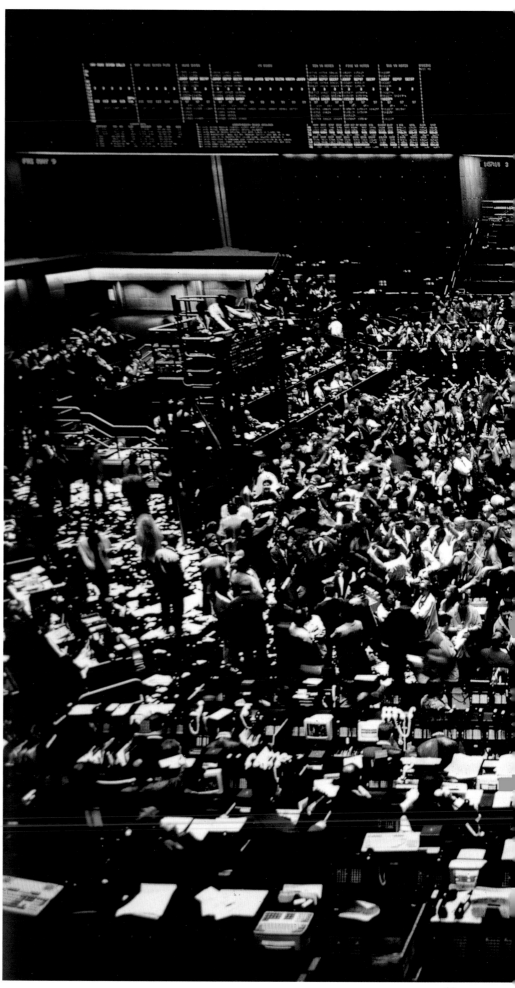

Andreas Gursky *Chicago Board of Trade* 1997. C-print. 72¼ x 95¼"

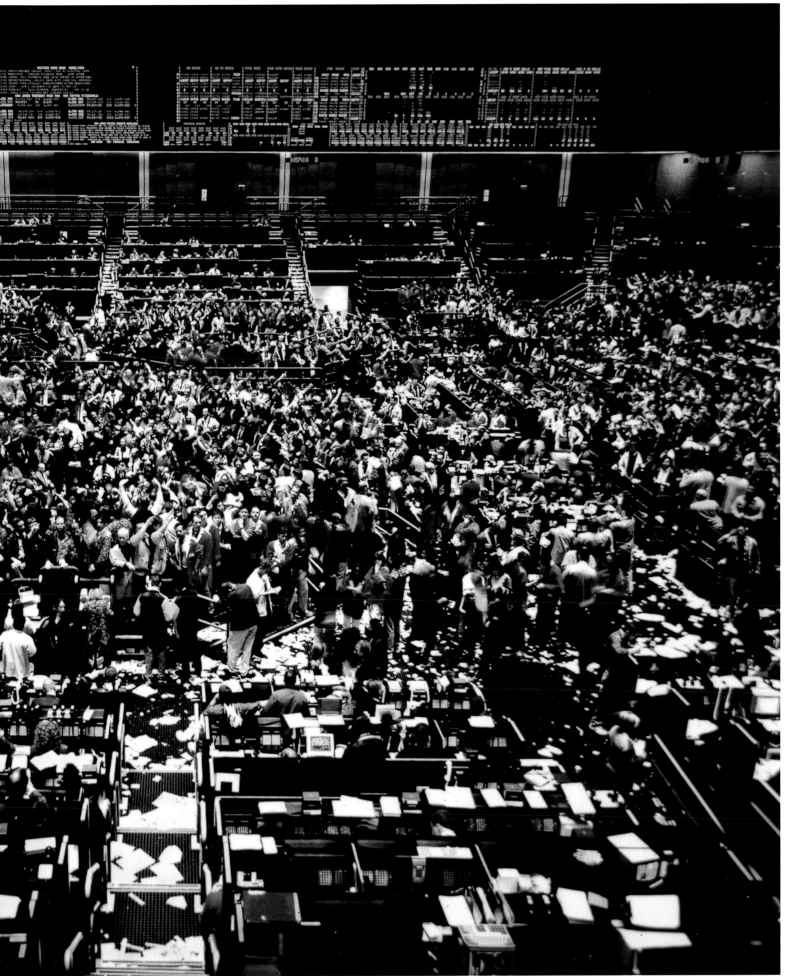

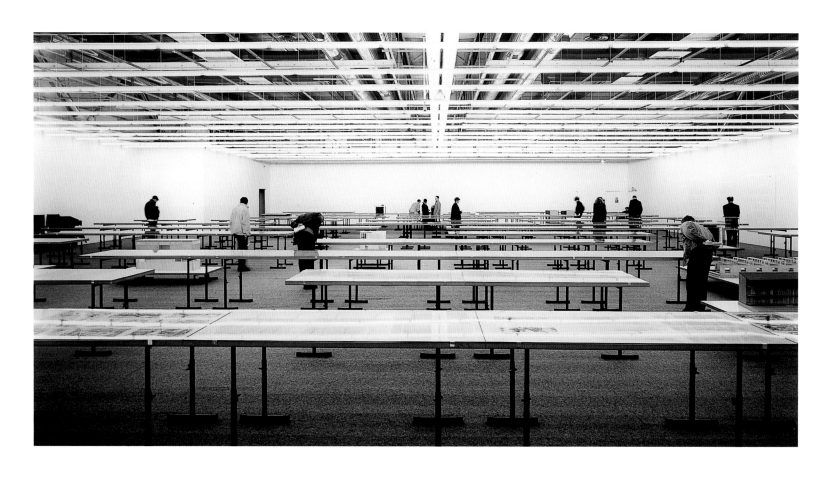

Andreas Gursky *Pompidou* 1995. C-print laminated on Plexiglas. 21¼ x 27½"

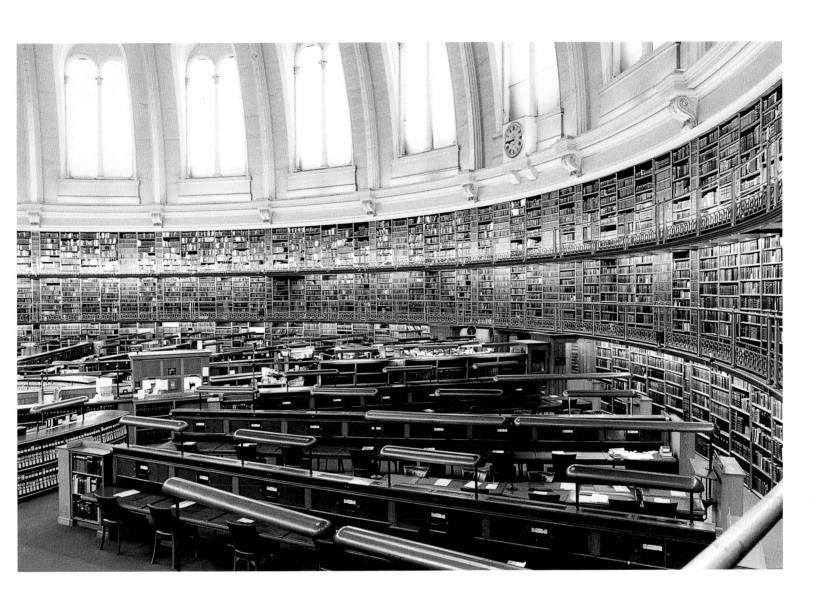

Candida Höfer *British Library London I* 1994. C-print. 15 x 22½"

Zhang Huan *1/2 (Meat #3) (Meat and Text)* 1998. C-print on Fuji archival paper. 60 x 49"

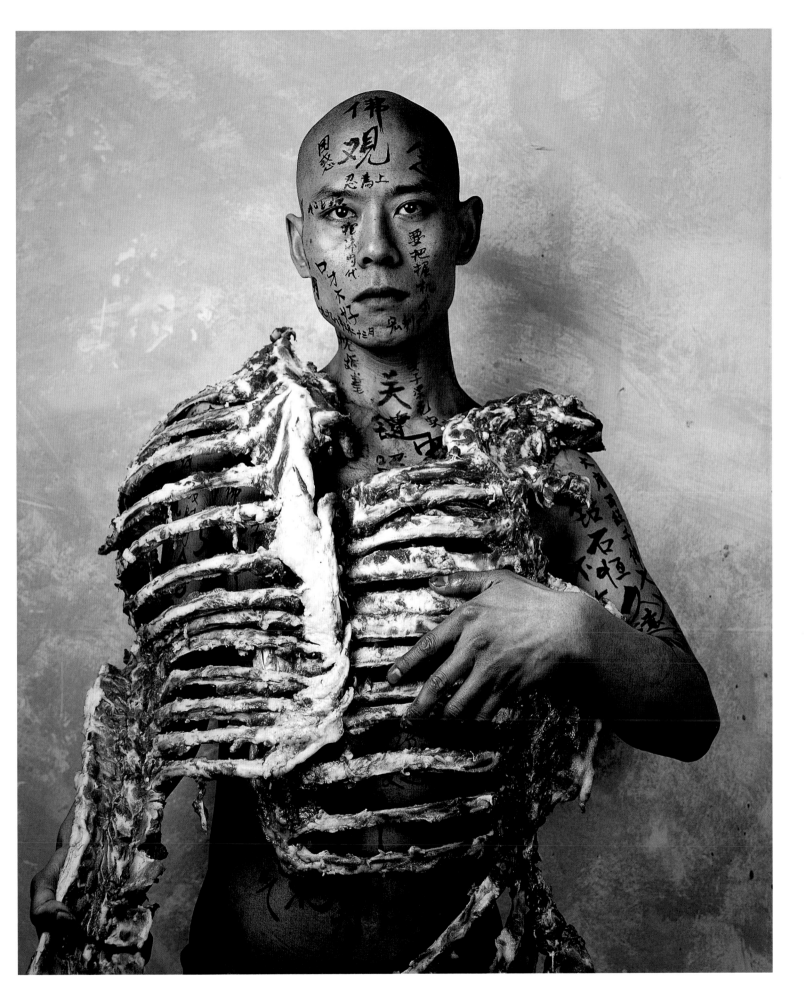

Gordon Matta-Clark *A W-Hole House* 1973. Vintage black-and-white photograph. 8 x 10"

Gordon Matta-Clark *A W-Hole House* 1973. Vintage black-and-white photograph. 8 x 10"

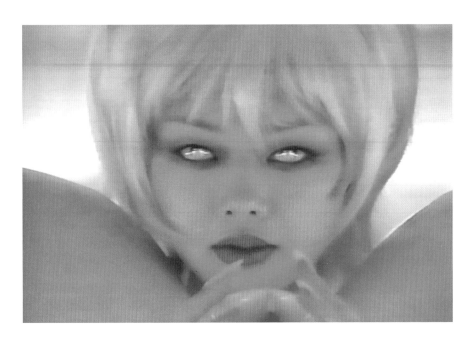

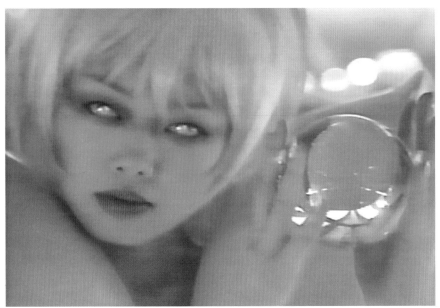

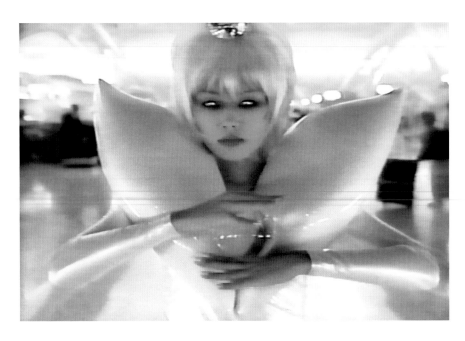

Mariko Mori *Miko no Inori* 1996. Video, color, sound. 29 min., 23 sec.

Bruce Nauman *Untitled* 1992. Fuji super-gloss print. 20 ⁵⁄₁₆ x 20"

Catherine Opie *Self-Portrait* 1993. C-print. 40 x 30"

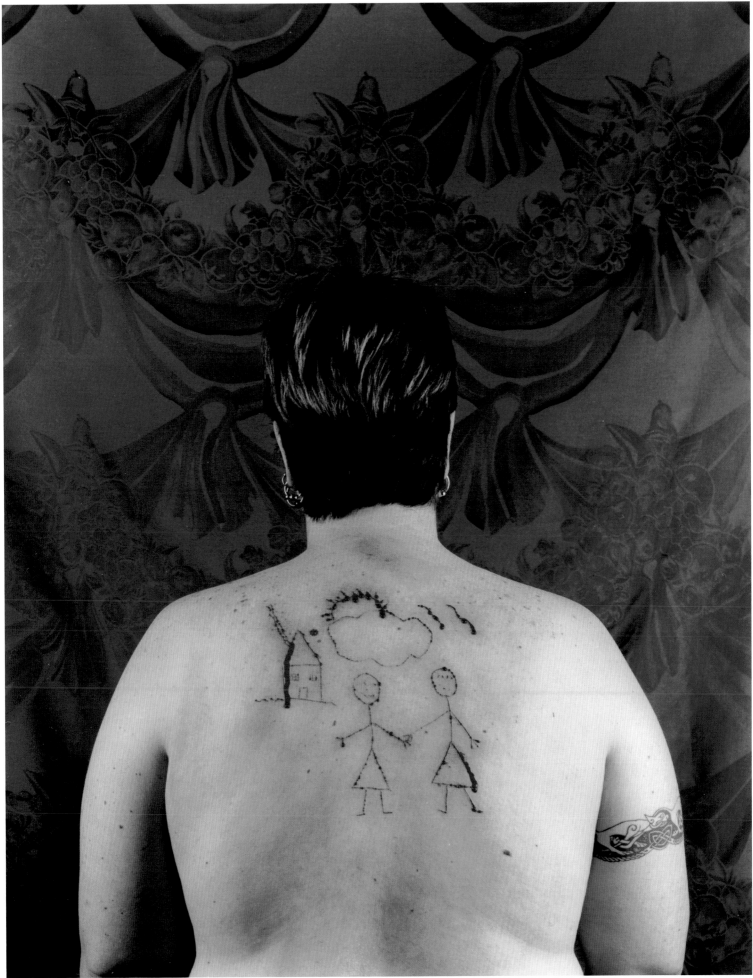

Gabriel Orozco *Focus Phillips* 1997. Cibachrome. 16 x 20"

Gabriel Orozco *El Sillon de mi Perro* 1991. Cibachrome. 16 x 20"

Gabriel Orozco *Socks I* 1995. Cibachrome. 16 x 20"

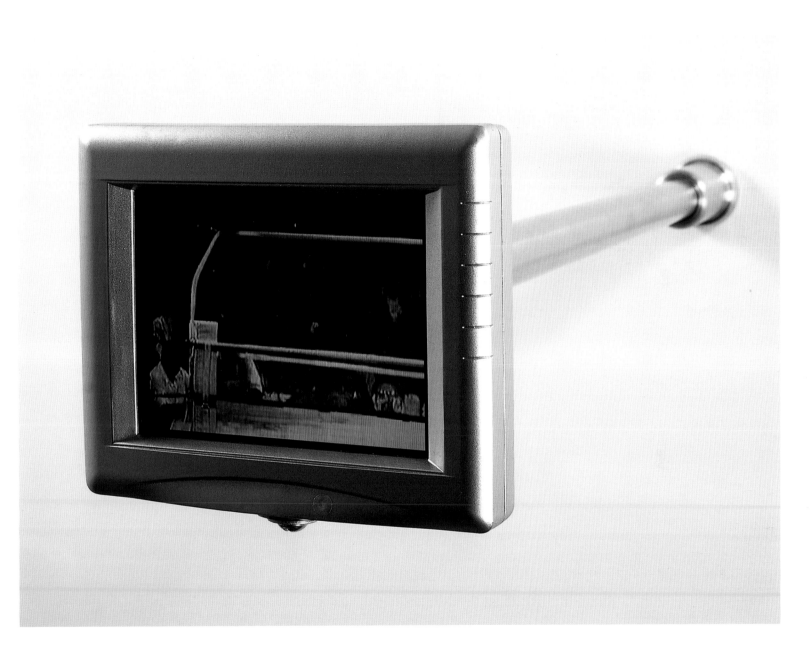

Paul Pfeiffer *Long Count III (Thrilla in Manilla)* 2001. LCD screen, DVD, mounting arm. Video: 3 min.; 6 x 7 x 60"

Richard Prince *Untitled (Four Women with Hats)* 1980. Ektacolor photographs. 20 x 24" each

Pipilotti Rist *I'm Not the Girl Who Misses Much* 1986. Video, color, sound. 5 min.

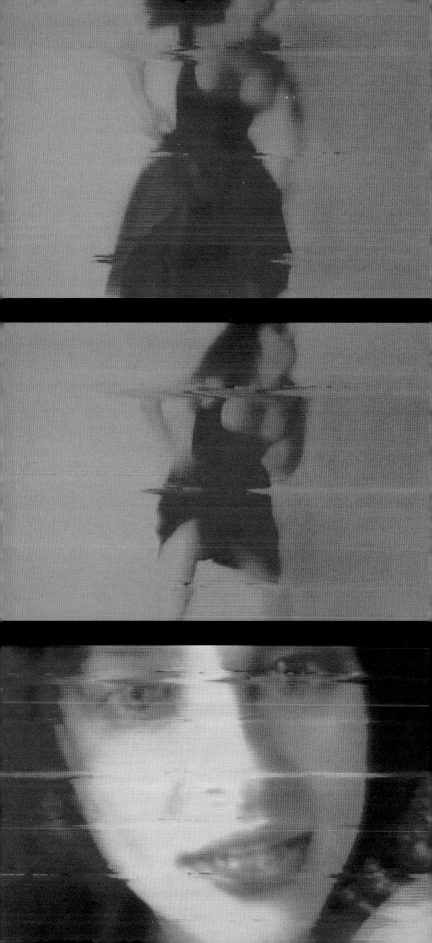

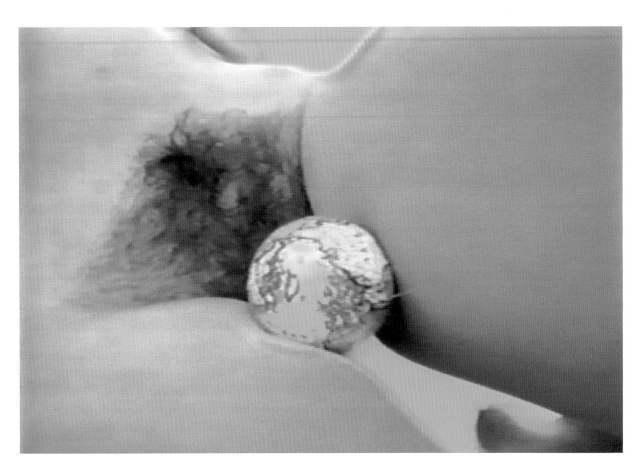

Pipilotti Rist *Pickel Porno* 1992. Video, color, sound. 12 min.

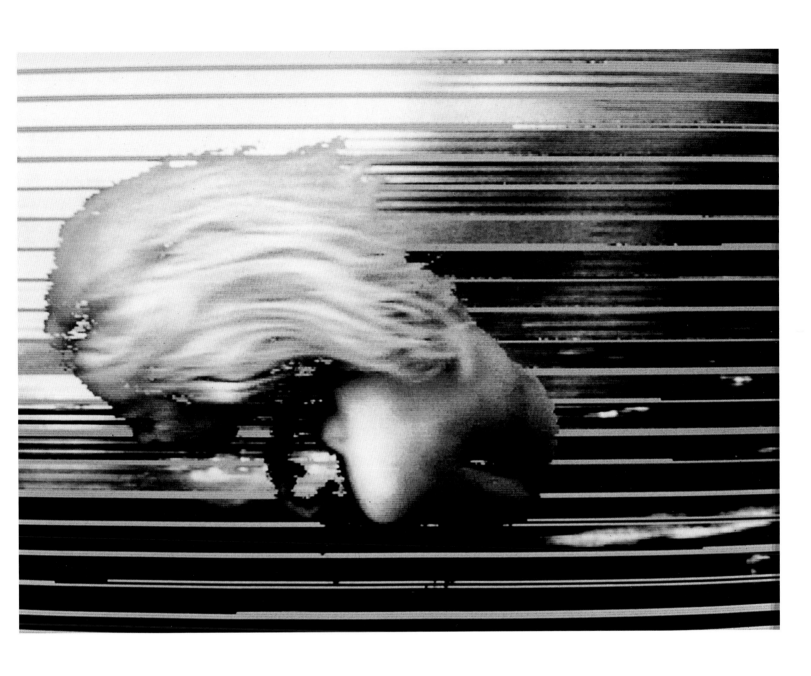

Pipilotti Rist *Untitled (Unselfish in the Bath of Lava)* 1994. Video still. 19 5/8 x 27 1/2″

Thomas Ruff *Untitled* 1989. C-print on Plexiglas. 77 x 61"

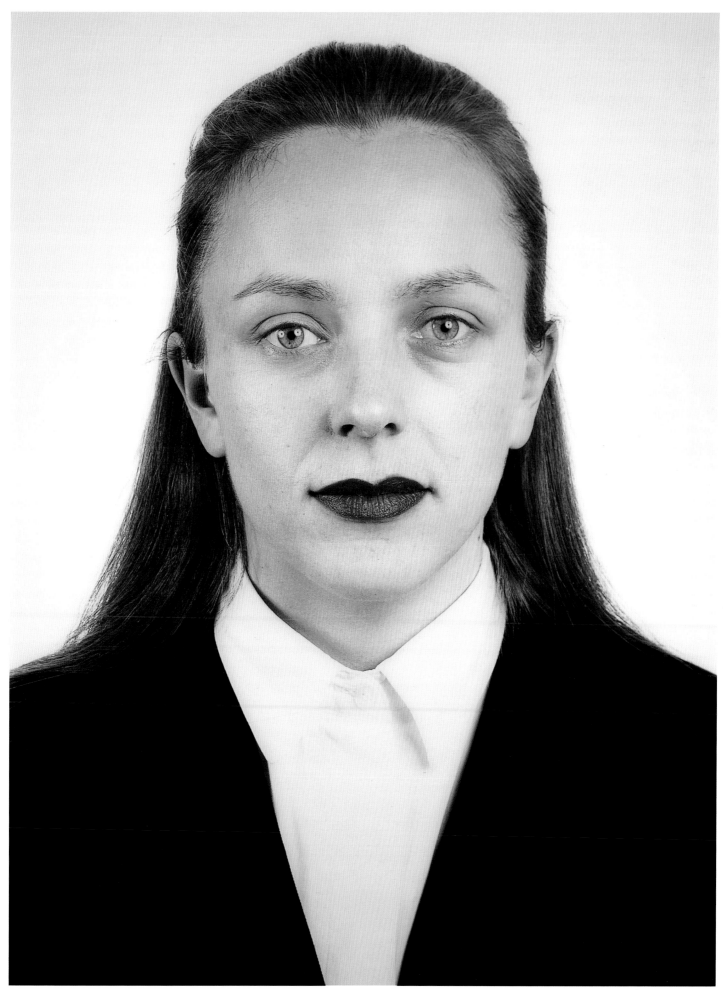

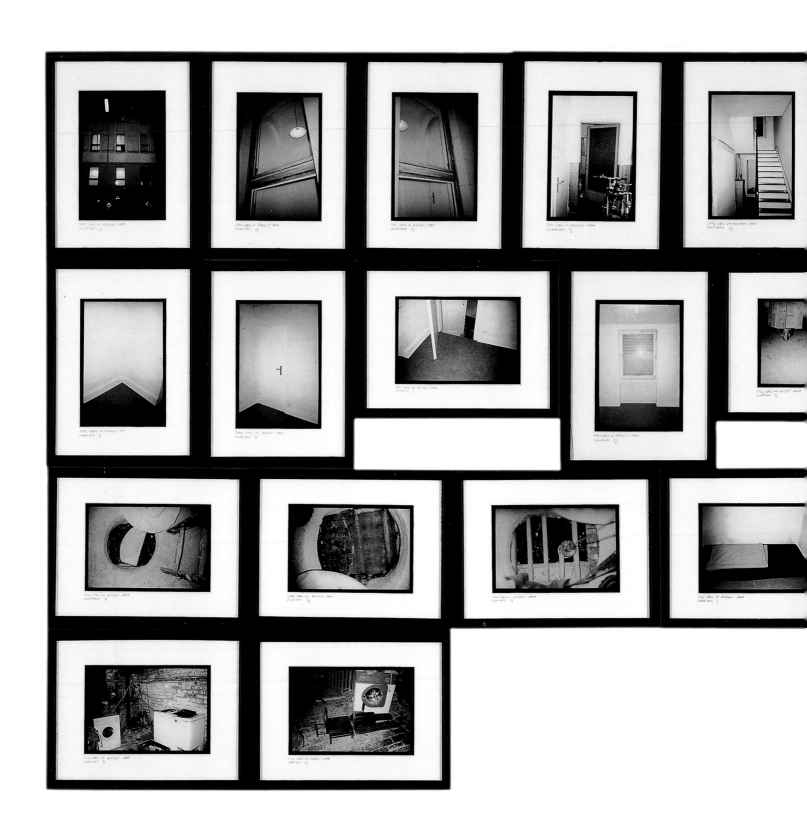

Gregor Schneider *Haus ur* 1985–97. Framed black-and-white photographs. 100 x 76" overall

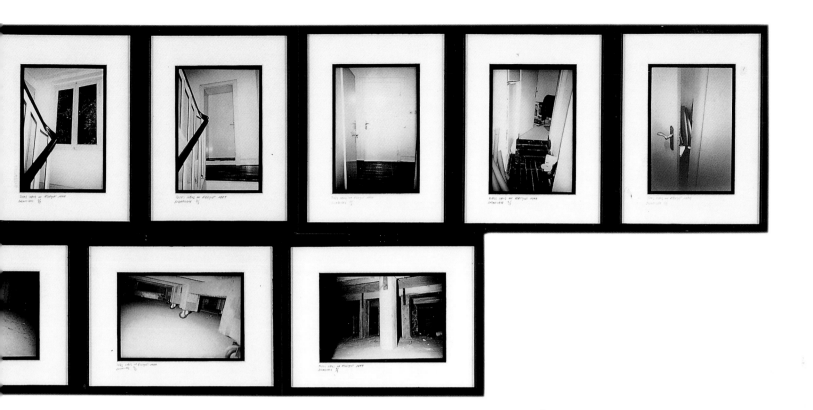

Cindy Sherman *Untitled (#132)* 1984. Color photograph. 67 x 47"

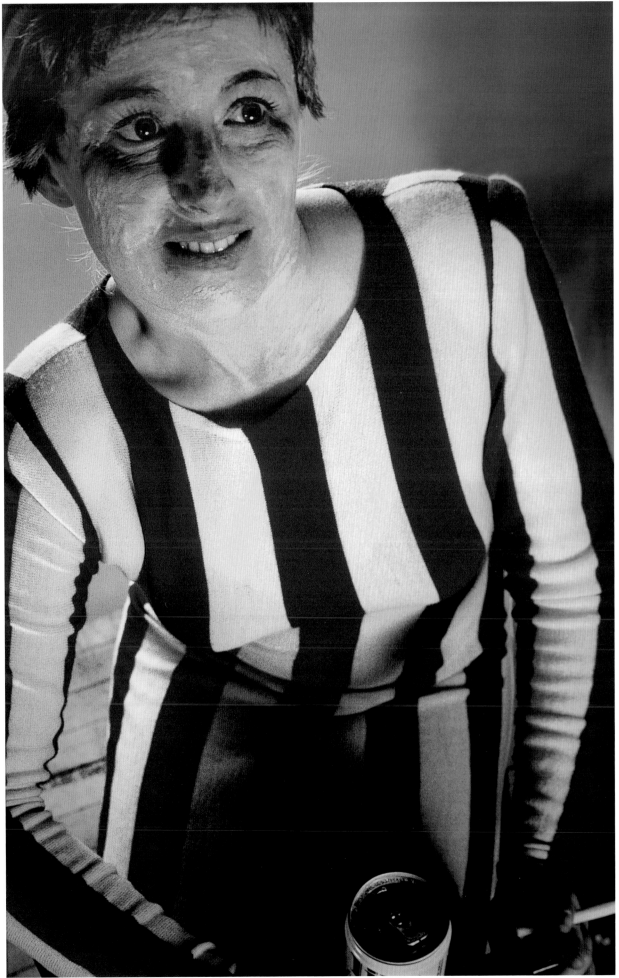

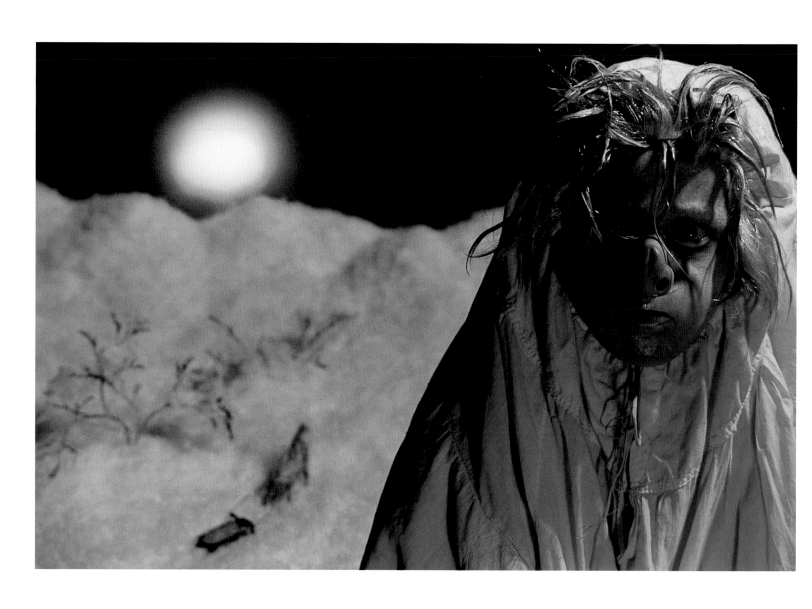

Cindy Sherman *Untitled* 1986. Ektachrome photograph. 20 x 24"

at her burial
I stood under
the tree next
to her grave

when I returned
the tree was a
distance from her
marker

Lorna Simpson *Magdalena* 1992. Six dyed diffusion Polaroid prints, two plastic plaques. 63 x 78" overall

Simon Starling *Burn Time* 2000. Two C-prints. 31 x 40" each

Thomas Struth *Veddeler Bruckenstrasse, Hamburg, 1986* 1986. Black-and-white photograph. 26 ½ x 33 ½"

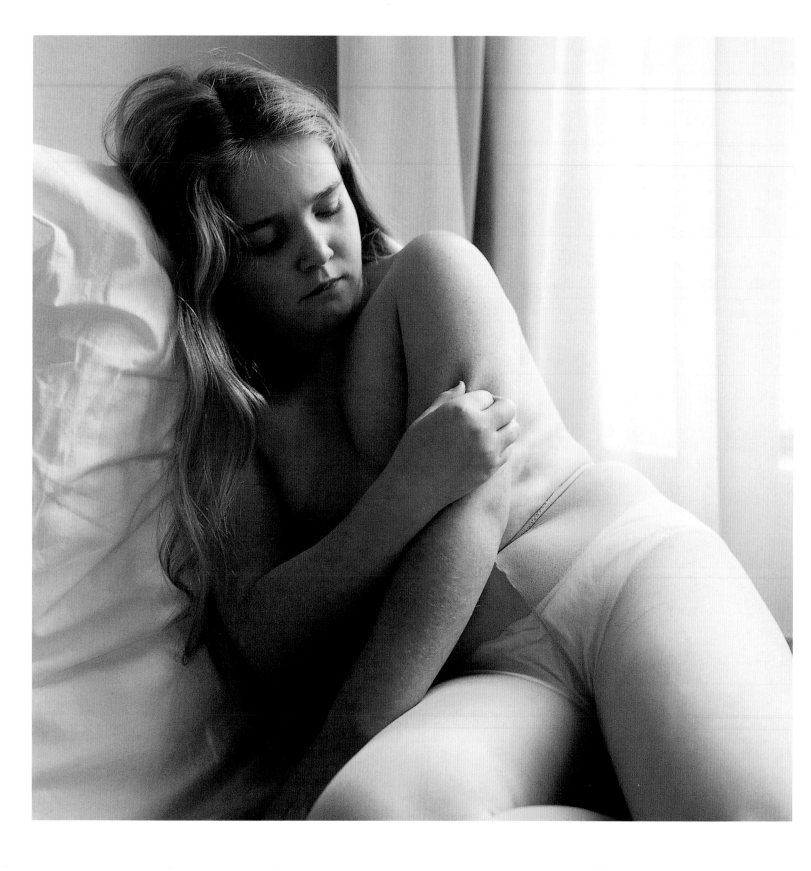

Hellen van Meene *Untitled* 1997–98. C-print. 11 x 11″

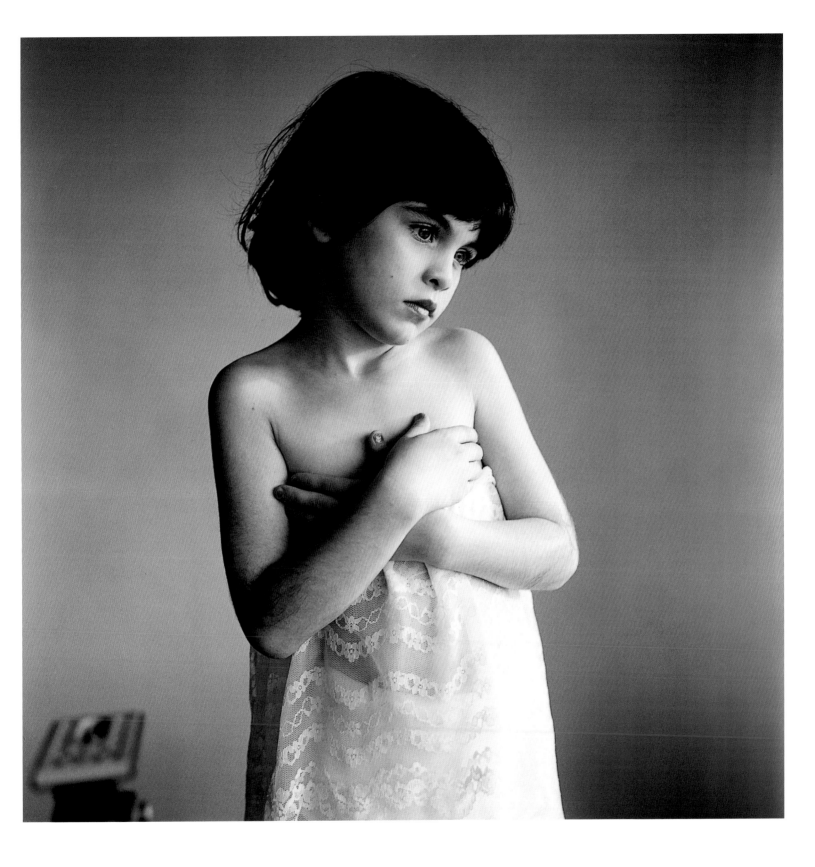

Hellen van Meene *Untitled* 1997–98. C-print. 11 x 11"

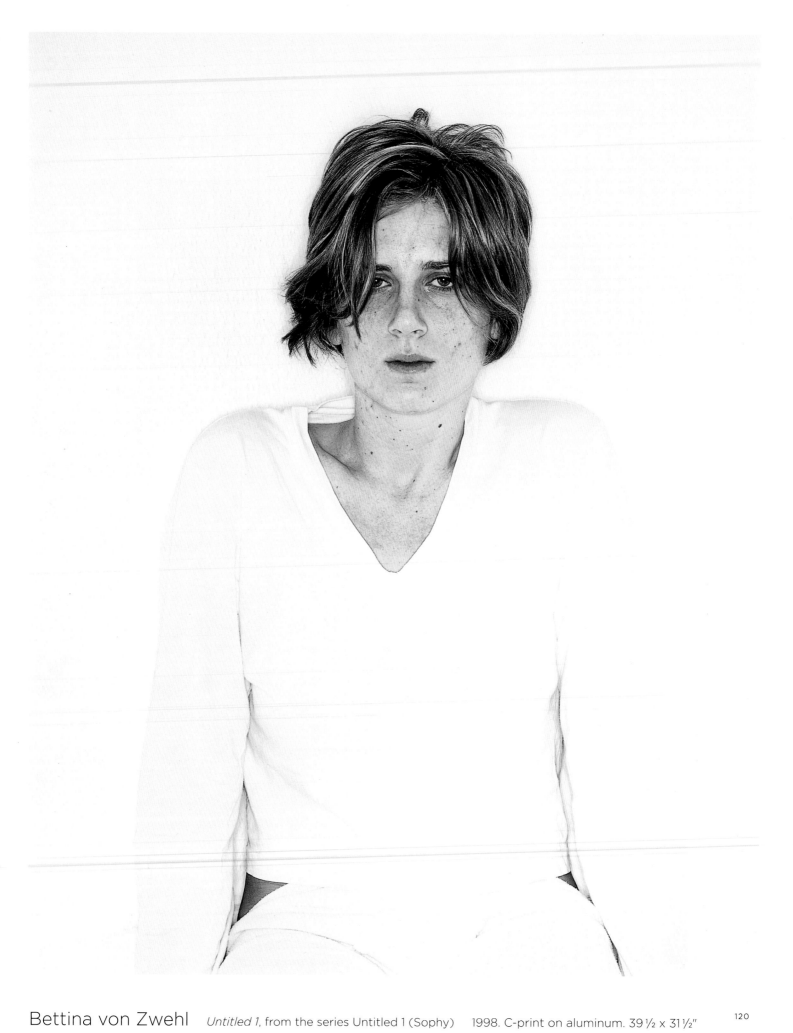

Bettina von Zwehl *Untitled 1*, from the series Untitled 1 (Sophy) 1998. C-print on aluminum. 39 ½ x 31 ½"

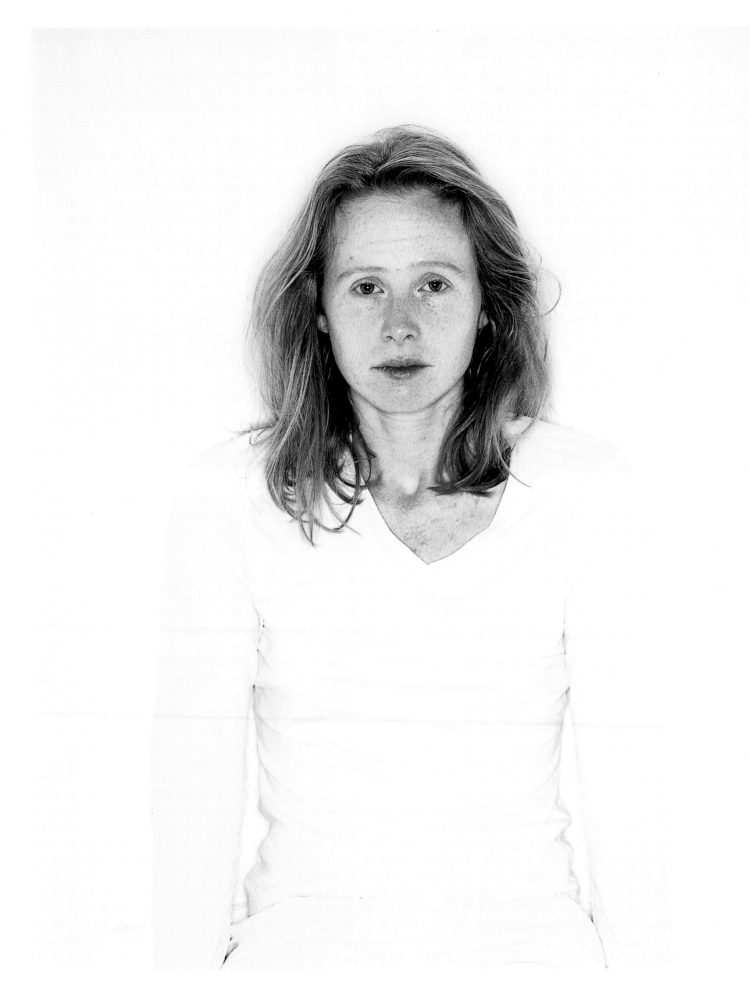

Bettina von Zwehl *Untitled 2*, from the Series Untitled 1 (Charlie) 1998. C-print on aluminum. 39 ½ x 31 ½"

Acknowledgments

THE PRESENT EXHIBITION was realized despite an extraordinary set of circumstances, both national and local in nature, many of which threatened to derail the project at almost every turn. The devotion of the Board of Trustees of the Contemporary Museum in Baltimore to this effort and the hard work of the staff kept us on track and are deeply appreciated. Special mention must be made of our immediate Past President, Steve Ziger, and our Treasurer, Dan Chemers. Our Director of Education, Leslie Shaffer, designed the public programs that accompany the show and, with her Curatorial Assistant, Tabatha Tucker, supervised the installation in Baltimore. Our Director of Development, Heather Marchese, was instrumental in overcoming the financial barriers to such an important exhibition. The major donors are listed separately in the catalogue. Gary Sangster, outgoing Chief Curator and Director of the Contemporary Museum, worked with Dennis and Debra Scholl's collection in Miami and helped choose the pieces to be displayed. We are grateful to our partners at the Palm Beach Institute of Contemporary Art, where the national tour begins, particularly Michael Rush, Director.

We consider the production of this catalogue to be a special event in the documentation of contemporary photography. We are grateful to our highly distinguished group of essayists, Nancy Spector, James Rondeau, and Michael Rush, who made time in their busy schedules at the Solomon R. Guggenheim Museum in New York, The Art Institute of Chicago, and the Palm Beach Institute of Contemporary Art, respectively, to prepare their insightful contributions. The award-winning graphic designer Miko McGinty has been in charge of the book's production; in no small measure, the lasting value of this publication to the critical literature will be due to her efforts. Our thanks go to Diana Murphy for her fine editing and to Julia Gaviria for her careful work with the text. Mark Koven was responsible for the majority of the excellent illustrations.

It goes without saying that the entire project would have been impossible without the enthusiastic participation and support of Debra and Dennis Scholl, dear friends of museums, artists, and curators everywhere, and perspicacious adventurers on the cutting edge of contemporary art.

— Michael Salcman

ALL COLLECTORS DREAM OF the opportunity to display their collections in a museum setting. This exhibition is the realization of such a dream for us.

Our heartfelt thanks go to Michael Salcman, who kept this project on track. Gary Sangster conceptualized the show and guided us every step of the way. Leslie Shaffer stepped in and brought the exhibition to completion, created the presentation, and installed the show with the assistance of William Downs.

Nancy Spector, James Rondeau, and Michael Rush are luminaries in the field of contemporary art, and we thank them for writing on the collection with such eloquence.

Miko McGinty has been more than an excellent designer, she has also led us through the entire publication process with patience and foresight. We appreciate the skillful editorial collaboration of Diana Murphy and Julia Gaviria. We echo Michael Salcman's thanks to Mark Koven for providing the wonderful photographs of many of the works that are illustrated in this book.

The exhibition would never have gotten off the ground without the organizational efforts, advice, and encouragement of Lisa Desmond. She has labored tirelessly throughout the process and we are especially indebted to her.

Our ability to see the collection cohesively has been informed in large part by the efforts of five curators — Connie Butler, Matthew Drutt, Douglas Fogle, Claudia Schmuckli, and Rochelle Steiner — who have installed the work in our home. Each has approached the task rigorously and generated results far beyond our expectations.

Bonnie Clearwater was instrumental early on in developing the concept of the collection. Dean Sobel has become a valued adviser in the course of this journey. Casey Kaplan has been a friend and mentor throughout our decade of building the collection. Of course, none of this would have been possible without the artists, who continue to amaze us with their energy and vision. We particularly want to thank Anna Gaskell; her creativity continues to inspire us.

We see our role as collectors as simply that of caretakers — to nurture the works and artistic endeavors by lending, helping fund difficult projects, and acquiring pieces for museums. In return, we receive the most enriching reward, exposure to new ideas.

— Debra and Dennis Scholl

PBICA Founders

Robert and Mary Montgomery

Contemporary Museum Board of Trustees

Michael Salcman, M.D., Acting President
Charles Brickbauer
Joyce Bucci
Daniel Chemers, Esq.
Sharon Drevitch Dondes
Neal M. Friedlander, M.D.
Jo Ann Fruchtman
Betsey Heuisler
Connie Imboden
Gary Kachadourian
Susan King
Barbara Kornblatt
Henry R. Lord, Esq.
Anthony McCarthy
Bodil Ottesen
Catherine Pugh
Anne Riggle
Dory Storms
Sandy Wise, Esq.
Steve Ziger, AIA

Imperfect Innocence **Sponsors**

Nancy B. and Howard K. Cohen
Carol and Alan Edelman
Bruce and Lindsay Fleming
Walter E. Gomez
Henry R. Lord, Esq.
Neil and Sayra Meyerhoff
Michael and Ilene Salcman

Artist Biographies

Amy Adler
Born: 1966, New York. Lives and works in London and Los Angeles
RECENT EXHIBITIONS:
2002
Amy Adler, photographs of drawings from photographs, UCLA Hammer Museum, Los Angeles
2001
Relative Positions, Contemporary Arts Museum, Houston, Texas

Doug Aitken
Born: 1968, Redondo Beach, California. Lives and works in Los Angeles
RECENT EXHIBITIONS:
2002
Aldrich Museum of Contemporary Art, Ridgefield, Connecticut
Louisiana Museum for Moderne Kunst, Humlebaek, Denmark
Museu d'Art Contemporani de Barcelona (MACBA), Spain
Fabric Workshop and Museum, Philadelphia, Pennsylvania
2000
Biennial Exhibition, Whitney Museum of American Art, New York

Janine Antoni
Born: 1964, Freeport, Bahamas. Lives and works in New York
RECENT EXHIBITIONS:
2002
Janine Antoni: taught tether teeter, SITE Santa Fe, New Mexico
2001
The Girl Made of Butter, Aldrich Museum of Contemporary Art, Ridgefield, Connecticut
ARCO 2001, Project Room, Madrid, Spain
1999
Imbed, Luhring Augustine Gallery, New York
1998
Swoon, Whitney Museum of American Art, New York

John Baldessari
Born: 1931, National City, California. Lives and works in Los Angeles
RECENT EXHIBITIONS:
2002
Marian Goodman Gallery, New York
2001
While something is happening here, something else is happening there: Works 1965–2001, Reykjavik Art Museum, Iceland
John Baldessari, The Overlap Series, Mai 36 Gallery, Zurich
2000-2001
Museo d'Arte Moderna e Contemporanea di Trento e Rovereto, Trento, Italy
1999
While something is happening here, something else is happening there: Works 1988–1999, Sprengel Museum Hannover, Germany; Staatliche Kunstammlungen, Dresden, Germany

Matthew Barney
Born: 1967, San Francisco, California. Lives and works in New York
RECENT EXHIBITIONS:
2002
Figure in the Landscape, Lehman Maupin Gallery, New York
1999-2000
CREMASTER 2: The Drones' Exposition, Walker Art Center, Minneapolis, Minnesota; San Francisco Museum of Modern Art, California
Picturing the Modern Amazon, New Museum of Contemporary Art, New York
1998
March with the Anal Sadistic Warrior, KunstKanaal, Amsterdam, The Netherlands
CREMASTER 5, Fundació La Caixa, Barcelona, Spain

Uta Barth
Born: 1958, Berlin, Germany. Lives and works in Los Angeles
RECENT EXHIBITIONS:
2002
ACME, Los Angeles
Tanya Bonakdar Gallery, New York
2001
Contemporary Arts Museum, Houston, Texas
2000
Uta Barth: nowhere near, Johnson County Community College Gallery of Art, Carlsen Center, Overland Park, Kansas
Henry Art Gallery, Seattle, Washington
Lannan Foundation, Santa Fe, New Mexico

Bernd and Hilla Becher
Born: Bernd Becher, 1931, Siegen District, Germany; Hilla Becher, 1934, Berlin, Germany. Live and work in Germany
RECENT EXHIBITIONS:
1999
Sonnabend Gallery, New York
1998
Comparative Concepts, International Center of Photography, New York
1996
Fraenkel Gallery, San Francisco, California
Daniel Weinberg Gallery, San Francisco, California

Jeff Burton
Born: 1963, Anaheim, California. Lives and works in Los Angeles
RECENT EXHIBITIONS:
2002
Galleria Franco Noero, Turin, Italy
2001
Casey Kaplan, New York
Galerie Emmanuel Perrotin, Paris

Miles Coolidge
Born: 1963, Montreal, Canada. Lives and works in Los Angeles
RECENT EXHIBITIONS:
2001
Acme, Los Angeles
Lannan Foundation, Santa Fe, New Mexico
2000
Orange County Museum of Art, Newport Beach, California

John Coplans
Born: 1920, London. Lives and works in New York
RECENT EXHIBITIONS:
2001
John Coplans: Self Portraits, Revolution, Detroit, Michigan
2000
Biennial Exhibition, Whitney Museum of American Art, New York
Art 31 Basel, Switzerland
1999–2000
Landscape, Andrea Rosen Gallery, New York

Gregory Crewdson
Born: 1962, Brooklyn, New York. Lives and works in Lee, Massachusetts
RECENT EXHIBITIONS:
2002
Gagosian Gallery, Beverly Hills, California
Luhring Augustine Gallery, New York
Gregory Crewdson Twilight, White Cube, London
2001
Gregory Crewdson: Photographs, SITE Santa Fe, New Mexico
2000
Gregory Crewdson: Disturbed Nature, Charles H. Scott Gallery, Emily Carr Institute of Design, Vancouver, Canada
1999
Surreal Suburbia, John Michael Kohler Art Center, Sheboygan, Wisconsin

Tacita Dean
Born: 1965, Canterbury, England. Lives and works in Berlin, Germany
RECENT EXHIBITIONS:
2001-2
Museu Serralves, Porto, Portugal
2001
Tacita Dean, Recent films and other works, Tate Modern, London
Museu d'Art Contemporani de Barcelona (MACBA), Spain

Thomas Demand

Born: 1964, Munich, Germany. Lives and works in Berlin

RECENT EXHIBITIONS:

2002

Städtische Galerie im Lenbachhaus, Munich, Germany

Castello di Rivoli, Turin, Italy

2001

Aspen Art Museum, Colorado

1999–2000

Carnegie International, Carnegie Museum of Art, Pittsburgh, Pennsylvania

Rineke Dijkstra

Born: 1959, Sittard, The Netherlands. Lives and works in The Netherlands

RECENT EXHIBITIONS:

2004

Herzliya Museum of Art, Israel

2003

The Art Institute of Chicago, Illinois

2002

Art & Public, Geneva, Switzerland

Willie Doherty

Born: 1959, Derry, Northern Ireland. Lives and works in Derry

RECENT EXHIBITIONS:

2002

Willie Doherty: Retraces, Matt's Gallery, London

2001

Willie Doherty: How it Was/Double Take, Ormeau Baths Gallery, Belfast, Northern Ireland

1999–2000

Carnegie International, Carnegie Museum of Art, Pittsburgh, Pennsylvania

1999

Dark Stains, Koldo Mitxelena Kulturunea, San Sebastian, Spain

True Nature, The Renaissance Society, Chicago, Illinois

1998–99

Somewhere Else, Tate Liverpool, England; Museum of Modern Art, Oxford, England

Stan Douglas

Born: 1960, Vancouver, Canada. Lives and works in Vancouver

RECENT EXHIBITIONS:

2002

Kestner Gesellschaft, Hannover, Germany; Serpentine Gallery, London; Galería Helga de Alvear, Madrid, Spain; Zeno X Gallery, Antwerp, Belgium

Journey into Fear, Contemporary Art Gallery, Vancouver, Canada; David Zwirner, New York

2000–2001

Stan Douglas: Le Detroit, Kunsthalle Basel, Switzerland; Winnipeg Art Gallery, Canada; Hamburger Bahnhof, Berlin, Germany; The Art Institute of Chicago, Illinois

Olafur Eliasson

Born: 1967, Copenhagen, Denmark. Lives and works in Berlin, Germany

RECENT EXHIBITIONS:

2002

Moving Pictures, The Museum of Modern Art, New York

Chaque matin je me sens différent, Chaque soir je me sens le même, Musée d'Art Moderne de la Ville de Paris, France

2001

Seeing yourself sensing, The Museum of Modern Art, New York

Your only real thing is time, The Institute of Contemporary Art, Boston

1999–2000

Carnegie International, Carnegie Museum of Art, Pittsburgh, Pennsylvania

Naomi Fisher

Born: 1976, Miami, Florida. Lives and works in Miami

RECENT EXHIBITIONS:

2002

Galleria Francesca Kaufmann, Milan, Italy

The Darkest Hour, Lombard-Fried Fine Arts, New York

2001

New Work Miami: Naomi Fisher, Miami Art Museum, Florida

Dara Friedman

Born: 1968, Bad Kreuznach, Germany. Lives and works in Miami, Florida

RECENT EXHIBITIONS:

2001

SITE Santa Fe, New Mexico

1998

Museum of Contemporary Art, Chicago

Total, Miami Art Museum, Florida

1997

Government Cut Freestyle, Miami Arts Project, Miami International Airport, Florida

Anna Gaskell

Born: 1969, Des Moines, Iowa. Lives and works in New York

RECENT EXHIBITIONS:

2002

The Menil Collection, Houston, Texas

2001–2002

Des Moines Art Center, Iowa

2001

resemblance, Casey Kaplan, New York

2000

by proxy, Aspen Art Museum, Colorado

1998–99

Museum of Contemporary Art, North Miami, Florida; Museum of Modern Art, Oxford, England; Astrup Fearnley Museum of Modern Art, Oslo, Norway; Hasselblad Center, Göteborg, Sweden

Robert Gober

Born: 1954, Wallingford, Connecticut. Lives and works in New York

RECENT EXHIBITIONS:

2002

Robert Gober: Sculpture and Drawings, San Francisco Museum of Modern Art

2001

United States Pavillion, Venice Biennial, Venice, Italy

1999

Robert Gober: Sculpture and Drawings, Walker Art Center, Minneapolis, Minnesota

Nan Goldin

Born: 1953, Washington, D.C. Lives and works in New York

RECENT EXHIBITIONS:

2002

Aperture 50 Years / The Art and Power of Photography, Aperture's Burden Gallery, New York

2000

Fogg Art Museum, Harvard University, Cambridge, Massachusetts

1999

Nan Goldin: Recent Photography, Museum of Contemporary Art, Houston, Texas

Douglas Gordon

Born: 1966, Glasgow, Scotland. Lives and works in Glasgow and New York

RECENT EXHIBITIONS:

2001

MOCA at the Geffen Contemporary, Los Angeles; Vancouver Art Gallery, Canada; Museo Rufino Tamayo, Mexico City; Hirshhorn Museum and Sculpture Garden, Washington, D.C.

Lisson Gallery, London

Tate Liverpool, England

Musée d'Art Moderne de la Ville de Paris, France

Dan Graham

Born: 1942, Urbana, Illinois. Lives and works in New York

RECENT EXHIBITIONS:

2002

Marian Goodman Gallery, New York

2001–2002

Dan Graham Works 1965–2000, Museu Serralves, Porto, Portugal; ARC/Musée d'Art Moderne de la Ville de Paris, France; Kröller-Müller Museum, Otterlo, The Netherlands; Museum of Contemporary Art Kiasma, Helsinki, Finland

2001

Dan Graham: Reflective Glass Moon Windows, Shima/Islands, Shigemori Residence, Kyoto, Japan

1999

Architekturmodelle, Kunst-Werke Berlin, Germany

Katy Grannan

Born: 1969 Arlington, Massachusetts. Lives and works in Brooklyn, New York

RECENT EXHIBITIONS:

2001

Casino 2001, Stedelijk Museum Voor Actuel Kunst Gent, Belgium

Legitimate Theater, Los Angeles County Museum of Art, California

2000-2001

Dream America, 51 Fine Art, Antwerp, Belgium; Lawrence Rubin Greenberg Van Doren, New York and Los Angeles

Andreas Gursky

Born: 1955, Leipzig, Germany. Lives and works in Düsseldorf

RECENT EXHIBITIONS:

2002

Centre Georges Pompidou, Paris

Museum of Contemporary Art, Chicago

2001

The Museum of Modern Art, New York

Candida Höfer

Born: 1944, Eberswalde, Germany. Lives and works in Cologne

RECENT EXHIBITIONS:

2002

Zwölf–Twelve, Documenta XI, Kassel, Germany

2001

Candida Höfer: Photographs, Rose Art Museum, Brandeis University, Waltham, Massachusetts

Candida Höfer. Douze. Twelve, Musée des Beaux Arts et de la Dentelle, Calais, France

Sonnabend Gallery, New York

2000

Orte Jahre. Photographien 1968–1999, Kunsthalle Nürnberg, Germany (catalogue); The National Museum of Photography, DET Kongelige Bibliotek, Copenhagen, Denmark

Zhang Huan

Born: 1965, An Yang City, He Nan Province, China. Lives and works in New York

RECENT EXHIBITIONS:

2001

Family Tree, Galerie Albert Benamou, Paris

Luhring Augustine Gallery, New York

Museo das Peregrinacións, Santiago de Compostela, Spain

The Power Plant Contemporary Art Gallery, Toronto, Canada

Gordon Matta-Clark

1943–1978

RECENT EXHIBITIONS:

2002

A W-Hole House, David Zwirner, New York

2000

Food, Magasin, Centre National d'Art Contemporain de Grenoble, France

1999

Reorganizing Structure by Drawing Through It: Drawings by Gordon Matta-Clark and Food, Westfälisches Landesmuseum für Kunst und Kulturgeschichte, Münster, Germany; Institute for Art & Urban Resources at P.S. 1, Long Island City, New York

Mariko Mori

Born: 1967 Tokyo, Japan. Lives and works in New York

RECENT EXHIBITIONS:

2002

Pure Land, Museum of Contemporary Art, Tokyo, Japan

1999-2000

Dream Temple, Prada Foundation, Milan, Italy; Rooseum Center for Contemporary Art, Malmö, Sweden

1999

Beginning of the End, Centre National de la Photographie, Paris

Bruce Nauman

Born: 1941, Fort Wayne, Indiana. Lives and works in New Mexico

RECENT EXHIBITIONS:

2001

Mapping the Studio I (Fat Chance John Cage), Dia Center for the Arts, New York

2000

"…the nearest faraway place…", Dia Center for the Arts, New York

Catherine Opie

Born: 1961, Sandusky, Ohio. Lives and works in Los Angeles

RECENT EXHIBITIONS:

2002

Icehouses and Skyways, Walker Art Center, Minneapolis, Minnesota

2000

In Between; Here and There, Saint Louis Art Museum, Missouri

The Photographer's Gallery, London; Museum of Contemporary Art, Chicago

Gabriel Orozco

Born: 1962, Jalapa, Veracruz, Mexico. Lives and works in New York and Mexico City

RECENT EXHIBITIONS:

2000-2001

The Museum of Contemporary Art, Los Angeles; Museo de Arte Contemporáneo Internacional Rufino Tamayo, Mexico City; Museo de Arte Contemporáneo de Monterrey, Mexico

1999-2000

Carnegie International, Carnegie Museum of Art, Pittsburgh, Pennsylvania

1999

Portikus, Frankfurt am Main, Germany

Centre pour l'Image Contemporaine, Geneva, Switzerland

Gabriel Orozoco: Photogravity, Philadelphia Museum of Art, Pennsylvania

Paul Pfeiffer

Born: 1966, Honolulu, Hawaii. Lives and works in New York

RECENT EXHIBITIONS:

2003

Museum of Contemporary Art, Chicago, Illinois

2002

The Long Count (Rumble in the Jungle), MIT List Center, Cambridge, Massachusetts

2001

The Project, Los Angeles

2000

Biennial Exhibition, Whitney Museum of American Art, New York

Richard Prince

Born: 1949, The Panama Canal Zone. Lives and works in upstate New York

RECENT EXHIBITIONS:

2002

Museum für Gegenwartskunst Basel, Switzerland

Kunsthalle Zürich, Switzerland

Kunstmuseum Wolfsburg, Germany

Barbara Gladstone, New York

2001

Regan Projects, Los Angeles

Pipilotti Rist

Born: 1962, Rheintal, Switzerland. Lives and works in Zurich

RECENT EXHIBITIONS:

2002

Outer and Inner Space: A Video Exhibition in Three Parts, Virginia Museum of Fine Arts, Richmond

2001

Apricots along the Street, Museo Nacional Centro de Arte Reina Sofia, Madrid, Spain

2000

Museum of Fine Arts, Montreal, Canada

Thomas Ruff

Born: 1958 Zell am Harmersbach, Germany. Lives and works in Düsseldorf

RECENT EXHIBITIONS:

2002

l.m.v.d.r., Contemporary Fine Arts, Berlin, Germany; Galeria Estrany de la Mota, Barcelona, Spain

Museum Folkwang, Essen, Germany; Museet for Samtidskunst, Oslo, Norway; Städtische Galerie im Lenbachhaus, Munich, Germany

Identificaciones, Museo Tamayo, Mexico City, Mexico

São Paulo Biennal, São Paulo, Brazil

Gregor Schneider
Born: 1969 Rheydt, Germany. Lives and works in Rheydt
RECENT EXHIBITIONS:
2003
Hamburger Kunsthalle, Hamburg, Germany
2002
Museum für Gegenwartskunst, Siegen, Germany
2001
German Pavilion, Venice Biennial, Italy
Kabinett für aktuelle Kunst, Bremerhaven, Germany
1999–2000
Carnegie International, Carnegie Museum of Art, Pittsburgh, Pennsylvania

Cindy Sherman
Born: 1954, Glen Ridge, New Jersey. Lives and works in New York
RECENT EXHIBITIONS:
2002
Gagosian Gallery, New York
2001
Nikolaj Copenhagen Contemporary Art Center, Denmark
Cindy Sherman: Early Works, Studio Guenzani, Milan, Italy
Metro Pictures, New York
1998
Allegories, Seattle Art Museum, Washington

Lorna Simpson
Born: 1960, Brooklyn, New York. Lives and works in Brooklyn
RECENT EXHIBITIONS:
2002
Lorna Simpson, Films and Photographs, Whitney Museum of American Art, New York; The Studio Museum of Harlem, New York
Centro de Arte Contemporáneo, Salamanca, Spain
2000
Addison Gallery of American Art, Andover, Massachusetts
1999–2001
Scenarios: Recent Works by Lorna Simpson, University of Michigan Museum of Art, Ann Arbor; The National Museum for Women in the Arts, Washington, D.C.; Sean Kelly Gallery, New York
1999
Walker Art Center, Minneapolis, Minnesota

Simon Starling
Born: 1967, Epsom, Surrey, England. Lives and works in Glasgow, Scotland
RECENT EXHIBITIONS:
2002
Inverted Retrograde Theme, USA, UCLA Hammer Museum, Los Angeles
Inverted Retrograde Theme, USA, Casey Kaplan, New York
2001
Secession, Vienna, Austria
Djungel, Dundee Contemporary Arts, Scotland

Thomas Struth
Born: 1954, Geldern, Germany. Lives and works in Düsseldorf
RECENT EXHIBITIONS:
2002-3
Museum of Contemporary Art, Los Angeles
2002
New Pictures from Paradise, Universidad de Salamanca, Spain
Dallas Museum of Art, Texas
2000–2001
Thomas Struth: My Portrait, The National Museum of Modern Art, Tokyo, Japan; The National Museum of Modern Art, Kyoto, Japan
1999
Thomas Struth STILL, Centre National de la Photographie, Paris; Gallery Shimada, Tokyo, Japan; Stedelijk Museum, Amsterdam, The Netherlands

Hellen van Meene
Born: 1972, Alkmaar, The Netherlands. Lives and works in Alkmaar
RECENT EXHIBITIONS:
2002
Museum of Contemporary Photography, Chicago
2001
portrait, Galleria Laura Pecci, Milan, Italy
1999
Conditions Humaines, Portraits Intimes, Mois de la Photo, Montreal, Canada

Bettina von Zwehl
Born: 1971, Munich, Germany. Lives and works in London
RECENT EXHIBITIONS:
2002
Galleria Laura Pecci, Milan, Italy
2001
Chelsea Rising, The Contemporary Arts Center, New Orleans, Louisiana
2000
Breathless! Photography and Time, Victoria and Albert Museum, London
An Anatomy of Control 2000, Lombard-Fried Fine Arts, New York

Photo Credits

Courtesy 303 Gallery, New York: 39, 41, 62–63

Courtesy Luhring Augustine, New York: 43

Natalia Benedetti: 22, 23, 24, 25, 73, 78–79, 96, 104–5, 106

Courtesy Tanya Bonakdar Gallery, New York: 70–71

Courtesy Luis Campana, Frankfurt: 21

Courtesy Frith Street Gallery, London: 60

Courtesy Barbara Gladstone, New York: 46, 47, 102–3

Courtesy Marian Goodman Gallery, New York: 45, 64, 100

Courtesy Katy Grannan: 86, 87

David Heald: 31

Courtesy Rhona Hoffman Gallery, Chicago: 115

Courtesy Casey Kaplan, New York: 14, 52, 74, 75, 76–77

Courtesy Kerlin Gallery, Dublin: 66, 67

Mark Koven: 17, 26, 29, 33, 37, 49, 50–51, 53, 54, 55, 56, 57, 65, 68–69, 72, 80, 81, 83, 84, 85, 90, 91, 93, 94, 95, 97, 107, 109, 110–11, 113, 114, 116, 118, 119, 120, 121

Ellen Labenski: 9, 11

Courtesy Matthew Marks Gallery, New York: 88–89

Courtesy Victoria Miro Gallery, London: 61

Michael James O'Brien: 46

Tom Powel: 10, 18

Courtesy The Project, A Space in Harlem, New York: 101

Courtesy Regen Projects, Los Angeles: 99

Chris Winget: 47

Courtesy David Zwirner, New York: 20

This publication accompanies the exhibition *Imperfect Innocence: The Debra and Dennis Scholl Collection* presented by the Contemporary Museum, Baltimore, Maryland, and the Palm Beach Institute of Contemporary Art, Lake Worth, Florida.

contemporarymuseum

January 11 – March 11, 2003
Contemporary Museum
100 W. Centre Street
Baltimore, Maryland 21201
(410) 783-5720
email: info@contemporary.org
www.contemporary.org

April 12 – June 15, 2003
Palm Beach Institute of Contemporary Art
601 Lake Avenue
Lake Worth, Florida 33460
(561) 582-0006
www.palmbeachica.org

This book was produced by Miko McGinty

Editor: Diana Murphy
Assistant Editor: Julia Gaviria
Designer: Miko McGinty

Printer: Artegraphica S.p.A., Verona

© 2003 Debra and Dennis Scholl

Gordon Matta-Clark works © 2002 Estate of Gordon Matta-Clark/
Artists Rights Society (ARS), New York

Published in 2003 by the Contemporary Museum, Baltimore, Maryland, and the Palm Beach Institute of Contemporary Art, Lake Worth, Florida.

Available through
D.A.P./Distributed Art Publishers
155 Sixth Avenue, 2nd Floor
New York, New York 10013
Tel: (212) 627-1999
Fax: (212) 627-9484
www.artbook.com

ISBN 0-9676480-3-3

PRINTED AND BOUND IN ITALY

FRONT COVER
Hellen van Meene. *Untitled* (detail). 1997–98. C-print. 11 x 11". Collection Debra and Dennis Scholl

BACK COVER
Thomas Struth. *Veddeler Bruckenstrasse, Hamburg, 1986* (detail). 1986. Black-and-white photograph. 26 ½ x 33 ½". Collection Debra and Dennis Scholl

PAGE 2
Doug Aitken. *The Mirror #11 (Rise)* (detail). 1998. Cibachrome laminated to Plexiglas. 30 x 35". Collection Debra and Dennis Scholl

PAGE 4
Uta Barth. *Field #7* (detail). 1995. Color photograph on panel. 23 x 28 ¾". Collection Debra and Dennis Scholl

PAGE 6
Thomas Demand. *Labor* (detail). 2000. Chromogenic print on photographic paper Diasec. 71 x 105 ½". Collection Debra and Dennis Scholl

SCI TR 645 .B352 C66 2003

Imperfect innocence